T0303748

CELEBRATING THE CITY OF SOUTHEND

DAVID C. RAYMENT

AMBERLEY

'GODESS of song ! that erst inspir'd the lays,
Of tuneful bards recording Baia's praise;
And thou sweet Nymph of Health, Hygeia lend
Thy welcome aid to celebrate South End.'

Thomas Archer (1793)

First published 2023

Amberley Publishing, The Hill, Stroud
Gloucestershire GL5 4EP

www.amberley-books.com

British Library Cataloguing in Publication Data.
A catalogue record for this book is available from the British Library.

ISBN 978 1 3981 1580 4 (print)
ISBN 978 1 3981 1581 1 (ebook)

Typesetting by SJmagic DESIGN SERVICES, India.
Printed in Great Britain.

Contents

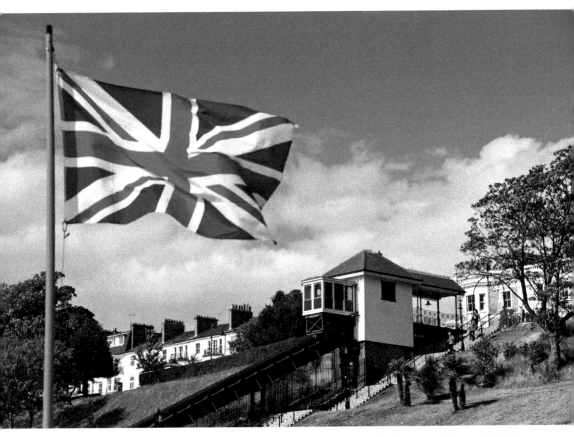

A small hamlet born of the ancient parish of Prittlewell, Southend, is one of Great Britain's premier seaside resorts, and now gives its name to what has become the fifty-second city of the United Kingdom.

Introduction:
The Making of a City

Prittlewell: 'In this parish is South End, noted for its delightful and retired situation; and, its sea-water being strongly impregnated with salt, it is becoming a place of great resort for company from London and other places in the bathing season.'
 Universal British Directory of Trade, Commerce and Manufacture (1790)

When Francis Drake navigated the *Golden Hind* along the River Thames to Deptford, where he was subsequently knighted by Queen Elizabeth I in 1581, it is unlikely he gave what is now Southend-on-Sea a second look. In those early days it was an unimportant strip of land on the north bank of the river at the south end of the ancient parish of Prittlewell, home to a church of Saxon origin and a priory of the early twelfth century. However, 200 years later the little hamlet that comprised of a few fishermen's huts was gaining recognition as a suitable place for sea bathing.

Indeed, the salubrious air, the saline qualities of the water and its closeness to the metropolis all helped to promote Southend as a place to visit. A site at the top of an acclivity with views across the Thames Estuary and of the Kent coast was chosen for the building of a terrace and a hotel. From here all the ships moving up the Thames could be seen on their way to the London wharves and later the growing number of London docks; or they could be seen anchored at the Nore, perhaps waiting to enter the mouth of the River Medway on their way to Sheerness Dockyard; or perhaps waiting to travel the extra 13 miles or so to Chatham, the launch site of HMS *Victory* in 1765, the vessel that became Vice-Admiral Nelson's flagship at the Battle of Trafalgar forty years later.

Building work on the terrace, including the Grand Hotel, had begun in 1790, with the hotel completed in 1793. This part of Southend was often referred to as 'New Southend'. At the foot of the cliff and to the east was 'Old Southend'. In 1793 some of the scattered buildings here were described in a poem by the London-born Thomas Archer, a curate at Prittlewell, as of 'lofty style' and of 'modern date', but others had been 'long erected' and of a 'lowly state'. New builds had commenced not only at the terrace, but also in juxtaposition to the old buildings on what is now Marine Parade. The Grand Terrace and Grand Hotel attracted the well-to-do

and the building's height above sea level afforded the visitors better views of the estuary than what could be seen from the buildings near sea level. Sunsets could be better seen too, as could the changing weather patterns above the Kent coast. Old Southend, or 'Lower Southend' as it was sometimes called, was not totally ignored by the higher echelons of society, however, for Caroline of Brunswick, the Princess of Wales, dined there at the Ship Tavern on several occasions in 1804.

Indeed, it was during the first decade of the nineteenth century, especially during the summer seasons, that New Southend became a place of beauty and fashion, a place to see, a place in which to be seen, and a place in which to catch up on high-society gossip. Lady Hamilton and Nelson's nieces all stayed at Southend, as did the much renowned opera singer Elizabeth Billington. Southend was also visited in 1801 by the London-based Count Simon Woronzow (Semyon Romanovich Voronstov 1744–1806), who was the Russian ambassador from 1784 to 1806.

It was during the first decade of the nineteenth century, however, that the London banker James Heygate began adding to his few existing land and property purchases in the area, building a sizeable portfolio. During the late 1820s James was one of the key people at Southend and his son William campaigned for Southend to have its own pier. The first pier, a wooden one, was built in 1830. A few years later Benjamin Disraeli (1804–81), the 1st Earl of Beaconsfield and later

Sunsets and the changing weather patterns over the Kent coast could be better seen from high up on the Terrace.

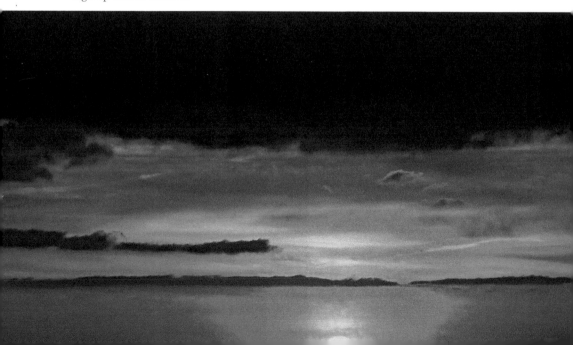

Prime Minister of the United Kingdom, stayed in Southend with the Heygates, occupying what is now the mayoral home, Porter's Grange. During the following decade Southend, which was for so long a part of the ancient Prittlewell parish, became a parish in its own right, with the opening in 1842 of a new church dedicated to St John the Baptist.

It was in 1855, however, that the building of the London, Tilbury & Southend railway line had reached nearby Leigh and was completed as far as Southend at the end of that year, with Southend station opening to the public on New Year's Day in 1856. Notable passengers during the early years of the railway included a son and daughter of Queen Victoria. They were Prince Arthur, who stayed at Southend in 1868, and Princess Louise, who stayed there five years later. In 1879, the Empress of France stayed at the Royal Hotel when her son, the Imperial Prince, was attending the Shoebury School of Gunnery. During the early 1880s the artist James Whistler visited the town to paint his watercolour seascapes, which included the old wooden pier.

Southend continued to grow at a fast pace and in 1889 a second railway line was completed with the opening of Southend Victoria station, thus visitors travelling by railway now had a choice of two entry points to the town. It would not be long before Southend became a thriving commuter town.

In 1890, the watchmaker Robert Arthur Jones arrived. He had moved to Southend from Stoke-on-Trent. Jones bought a watchmaking business in the High Street and in 1917 he used some of his profits to purchase Prittlewell Priory and its

Southend became a parish in its own right when St John the Baptist Church opened in 1842.

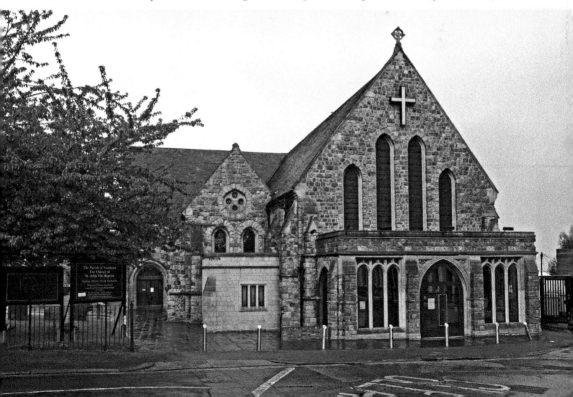

surrounding land, which he gave to Southend Council for the benefit of Southend inhabitants.

It was in 1892, however, that the whole of the parish of Prittlewell was incorporated into the new borough of Southend and its first mayor, Thomas Dowsett, was appointed. Nine years later, the Kursaal building, with its 60-foot-diameter dome, was opened and in 1912 a funicular railway was installed on the cliff, allowing passengers easy access down the cliff to the Western Esplanade and the seafront.

Leigh-on-Sea and a part of Eastwood joined the borough in 1913, and Southend was afforded 'County Borough' status in 1914, the same year in which the First World War began. The Park Inn Palace Hotel, which was completed in 1901 as the Metropole Hotel but did not become fully operational until 1904, served as a hospital for returning soldiers who were wounded in battle. During this period the hotel was known as 'The Queen Mary Hospital'. It was visited by Princess Louise on a private visit in 1915 and in 1917 it was visited by Princess Mary who, when arriving at the town, was accompanied for 8 miles along the railway track by five training aircraft forming a guard of honour. When the war ended in 1918 Southend life began to return to normal. In 1933, Shoeburyness was absorbed into the borough, as was North Shoebury, more of Eastwood, and parts of Great Wakering and Shopland. At the time it was reported in *The Newsman* that Alderman Robert Tweedy-Smith, mayor of Southend in 1924–25 and 1932–33,

Moonrise at the Kursaal. The dome building of the Kursaal was first opened in 1901.

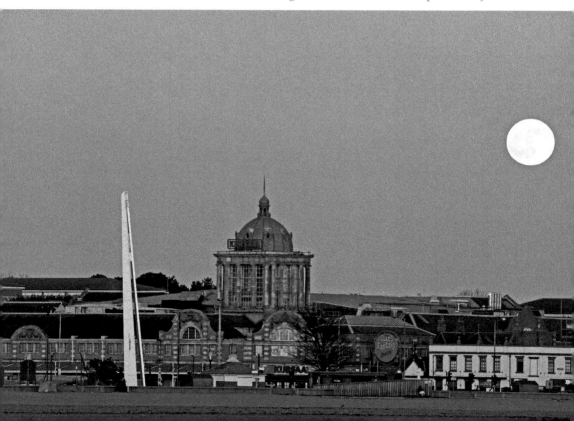

Leigh High Street. Leigh-on-Sea became part of the borough of Southend in 1913.

when speaking at a luncheon said that 'they [Southend] were becoming important enough to look forward to the time when they would become a city'. In 1935, the Southend Municipal Airport was opened on land that was used by the Royal Flying Corps during the First World War.

Six years after Tweedy-Smith's luncheon speech the country was again at war. Situated on the north bank of the Thames Estuary all seagoing vessels on their way to and from London and Chatham had to pass Southend's shores, thus Southend-on-Sea was a strategic site for the control of Royal Navy and merchant shipping. The Terrace was occupied by military personnel, as was the pier, which was temporarily named HMS Leigh. The army was employed to install a special deck on the Prince George extension so that it could accommodate anti-aircraft guns that stood on concrete emplacements. In March 1945, the Home Office gave permission for most of the pier, except the extension, to be reopened to the public. The *Chelmsford Chronicle* reported 79,000 people had been on the pier during the first nineteen days. The pier was not fully derequisitioned, however, until 30 September. In 1946, Southend life again had returned to normal and in the summer of 1947 it was possible to board the *Royal Daffodil* at Southend Pier for a sightseeing trip to the French coast, but passengers were not allowed to land on French soil. They only had one stop for six hours at Margate, Kent.

The post-war years (1950s and 1960s) were Southend's heyday, attracting visitors from far and wide, but especially from East London. They could relax

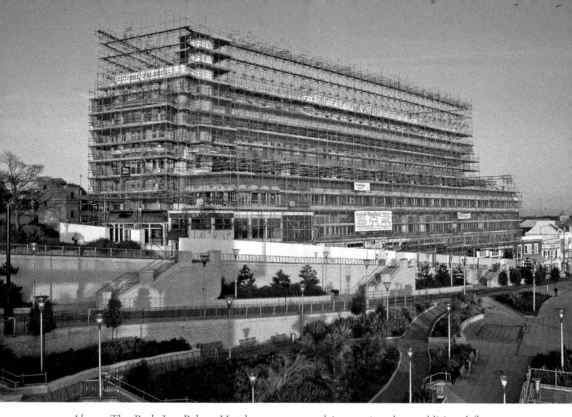

Above: The Park Inn Palace Hotel was renovated in 2006 and an additional floor was added to the rooftop.

Below: The Park Inn Palace Hotel is now part of the Raddison Hotel Group.

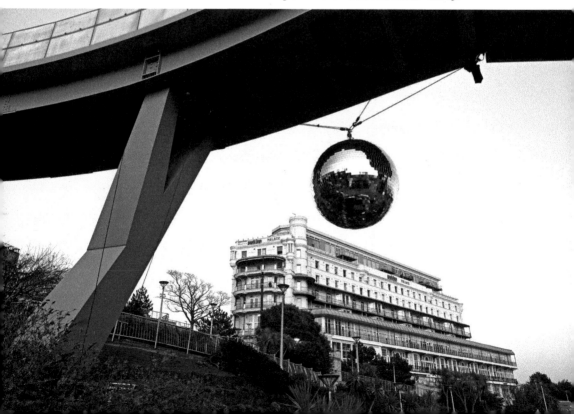

in one of the many deckchairs available on the seafront or perhaps visit one of the amusement arcades on Marine Parade if the weather was unfavourable for sunbathing. At the end of 1963 the town was invaded by Beatlemania when four young lads from Liverpool performed numbers from their albums, *Please Please Me* and *With the Beatles*. Their hit singles at the time were the numbers 'She Loves You' and 'I Wanna Hold Your Hand', which became the Christmas number one. In June the following year it was the jellyfish – not another pop group, but the marine animals – that invaded Southend beaches.

Southend-on-Sea continued to thrive. In the late 1960s and early 1970s new developments took place north of the High Street at Victoria Avenue, which included the building of the Victoria Shopping Centre, the new Civic Centre, and another building which was to house staff working for HM Customs and Excise.

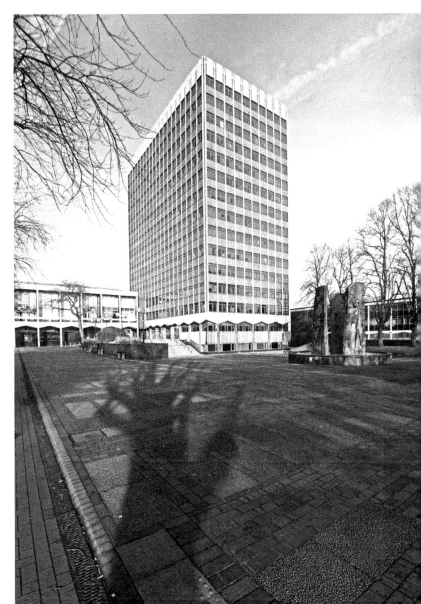

The Civic Centre tower building in Victoria Avenue.

Alexander House, the former Customs & Excise building, later occupied by HM Revenue and Customs after the amalgamation of Customs & Excise and the Inland Revenue.

A few of the household names attracted to the town were C&A Modes, Boots, British Home Stores, Marks and Spencer, Debenhams and Sainsbury's. A later addition was Primark, which once traded in the Royals Shopping Centre but now occupies the building that previously housed British Home Stores.

In 1999, Southend was twinned with the Polish seaside city of Sopot. Sopot, which is on the Baltic coast, also has a pier which is apparently the longest wooden one in Europe.

Then, in 2003, there was the magnificent discovery of a seventh-century Anglo-Saxon burial chamber at Prittlewell, which was excavated by the Museum of London Archaeology Service. The inhabitant of the chamber is often referred to as the 'Prittlewell Prince' but may actually have been a Saxon king. Items found in the chamber were put on permanent display at Southend Central Museum, giving visitors an insight into Southend's Anglo-Saxon past.

In 2010, the area between Victoria Avenue and the High Street began to be modernised. The roundabout was replaced with a new traffic-light system, which was completed in 2011.

In 2015, one of Southend's most prominent figures, David Amess, who was the MP for Southend West from 1997 and previously an MP for Basildon, was knighted. For many years Sir David had campaigned vigorously for his beloved

Above: North end of the High Street in 1981. On the left shops include John Walton, Manfield, Stead and Simpson, Susan Reynolds Books, Miss Selfridge, Boots, Richard Shops, Peter Lord, Leeds Permanent and Hepworth.

Below: People pass the Royals Shopping Centre at the south end of the High Street when walking to the seafront during the platinum jubilee weekend.

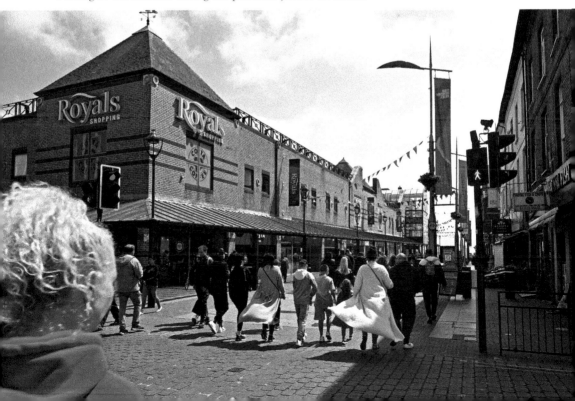

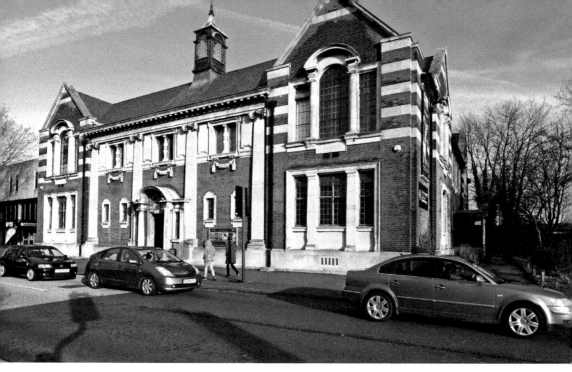

Above: The Southend Central Museum and Planetarium in Victoria Avenue is a Grade II listed building that was first opened as a library in 1906 and houses artefacts found at the Saxon burial chamber in Prittlewell.

Below: In 2010 work began to remove the Victoria Circus roundabout and replace it with a new traffic light system.

Southend to acquire city status. He was stabbed to death on 15 October 2021 in an act of terrorism while holding a constituency surgery at Belfairs Methodist Church in Leigh-on-Sea. A few days later then Prime Minister Boris Johnson announced the queen would grant Southend city status in honour of Sir David. Prince Charles, the longest serving Prince of Wales in history and representing the queen, visited Southend on 1 March 2022 when he presented the then mayor of Southend, Margaret Borton, with the letters patent, officially marking Southend as the United Kingdom's fifty-second city. Councillor Borton had the privilege of being the last mayor of the borough of Southend and the first mayor of the city of Southend. The prince was accompanied by the Duchess of Cornwall during his visit and the royal couple later visited Southend Pier where they unveiled one of the new eco-friendly pier trains, named *Sir David Amess*. Unfortunately, Sir David did not live to see his dream of Southend achieving city status come true, a dream that became reality nearly ninety years after Tweedy-Smith's luncheon speech.

Sir John Betjeman once said, 'Southend is the Pier, the Pier is Southend.' Certainly, that structure is a foundation for continuity in an otherwise changing landscape; but it is the actors from all walks of life, which tread the boards of Southend's stage, past and present, that make the city of Southend what it is today.

One of the new eco-friendly pier trains; it is named after the late Sir David Amess.

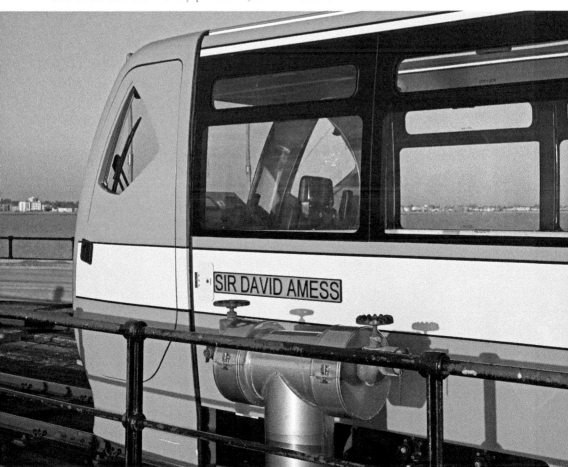

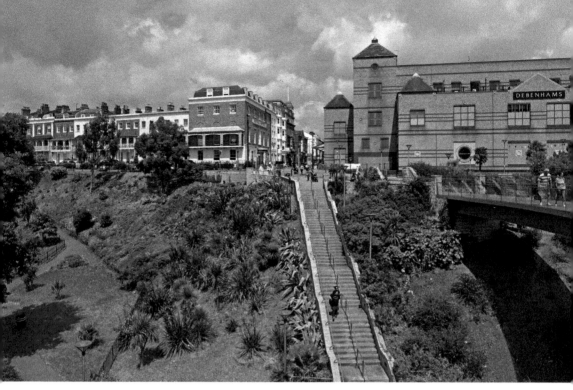

Above: Left of centre, on the west side of the High Street, is the 1790s-built Royal Hotel and Royal Terrace. On the east side is the late 1980s-built Royals Shopping Centre. Nearly 200 years separate the two builds.

Below: A closer view of the Royal Hotel (centre) on the corner of the High Street, with the Royal Terrace on the left.

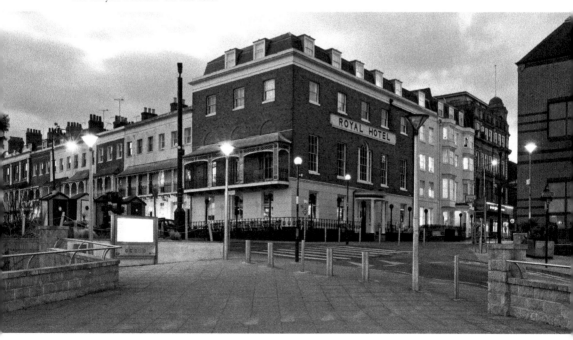

Thomas Archer and Revd Sir Herbert Croft

'Where Thames in ampler current laves the shore,
With ocean soon to join his liquid store;
Hard by the princely rivers northern bound,
The ancient town of Prittlewell is found.'

Thomas Archer (1793)

The aforementioned Thomas Archer, who wrote *A Poetical Description of New South-End*, was the son of Revd Thomas Archer and his wife Mary. Thomas Sr was a domestic chaplain to Ann O'Brien, 2nd Countess of Orkney and Inchiquin,

The curate Thomas Archer and Revd Sir Herbert Croft were both at St Mary's, Prittlewell.

and he was also the rector of St Martin Ludgate, London. Thomas Jr was born in London on 25 March 1750 at Foster Lane and was baptised there on 7 April at the church dedicated to Christ Church and St Leonard. His second wife was Susanna Page whom he married on 18 January 1780 at All Saints' Church, North Benfleet. Thomas was a curate at Rawreth, North Benfleet, Prittlewell and Southchurch. He was a stipendiary curate at Pitsea and a rector of Foulness. He died in 1832 and was buried at Foulness by his own request. Susanna died in 1847, at the age of eighty-six.

When Thomas was a curate at Prittlewell the rector there was Herbert Croft (1751–1816). He was the son of another Herbert Croft, whose father, Francis, was the brother of Sir Archer Croft, the 2nd Baronet. Sir Archer Croft was succeeded by his son, another Sir Archer Croft who, in turn, was succeeded by Sir John Croft, 4th Baronet. Sir John died without issue in 1797. The title went to his cousin, Herbert Croft, the rector of Prittlewell, who at one time was a chaplain to the garrison at Quebec. Herbert married twice: first to Sophia Cleave, who died in 1792; then to Elizabeth Lewis, whom he married in 1795. In 1801, Herbert and Elizabeth were living at the Terrace in New Southend. Revd Sir Herbert Croft's sister, Mary Croft, married Thomas Ryder of Hendon when she was still a minor. Herbert Croft Jr and his father were witnesses at the wedding. Thomas and Mary Ryder's daughter, Mary Frances Ryder, married Revd Alexander John Scott, who was a friend and chaplain to Nelson on board the *Victory* at the Battle of Trafalgar. Revd Scott was later a curate at Burnham-on-Crouch and he was rector of nearby Southminster.

Early Royal Visits

Princess Charlotte Augusta (1796–1817)

The first royal visitor to stay at Southend appears to have been Princess Charlotte Augusta, the only child of the then Prince of Wales (later George IV) and his cousin Caroline of Brunswick. Charlotte arrived at Southend on Tuesday 1 September 1801 at around 5 p.m. She stayed at the Lawn in Southchurch, the home of Thomas Sumner (1747–1815) and his wife, Elizabeth, who died at Kentish Town, London, in 1806. Thomas was a magistrate and deputy lieutenant for Essex. Thomas Archer refers to Sumner in his *New South-End* poem:

> 'To Southchurch, and the Lawn, direct your reigns,
> The pleasing view shall well reward your pains;
> Where S-mn-r dwells, of worth and fame approv'd,
> A character by all rever'd and lov'd.'

The princess was accompanied to Southchurch by her governess, Lady Martha Bruce (1739–1810), more commonly known as Lady Elgin, the Countess of Elgin. Lady Elgin was the mother of Thomas Elgin (1766–1841) who, when he was British ambassador to the Ottoman Empire, collected sculptures at the Temple of Athena (Parthenon) on the Acropolis in Athens. Known as the 'Elgin Marbles', these sculptures were brought to England and can be seen on display at the British Museum in London.

On 26 September, however, the five-year old princess, who frequently went bathing when at Southend, was in the library opposite the Grand Hotel (now Royal Hotel). It was reported in the *Mirror of the Times* on 3 October that Lady Elgin insisted no person should be admitted while the princess was there as she was 'very timid and could not bear the fatigue of being crowded'. The use of the word 'timid' is perhaps a little unfair for Princess Charlotte did not appear to lack confidence in her walks by the sea. It was reported in the *Morning Post* of 17 September that she is a lively child and that she 'curtsies, or nods, or kisses the back of her hand to everyone she meets'.

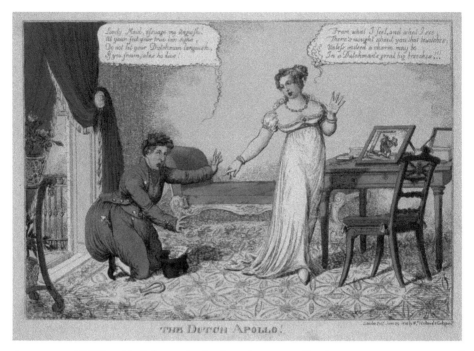

A cartoon of William II of the Netherlands and Princess Charlotte Augusta. (Courtesy of the Library of Congress)

Princess Charlotte enjoyed strolling on the beach whenever she was at the seaside and liked to collect species of seaweed, especially those specimens from which she could make necklaces out of the black 'berries'.

Princess Charlotte and Lady Elgin left Southend for Shooter's Hill on Friday 9 October, stopping on the way to dine at the home of Sir John Smith-Burgess in Havering-atte-Bower. She therefore stayed at Southchurch for nearly six weeks. Princess Charlotte would have succeeded her father to the throne but she predeceased him, dying in childbirth. She is buried at St George's Chapel, Windsor Castle.

Princess Caroline Amelia Elizabeth (1768–1821)

In 1804, it was the turn of Princess Charlotte's mother to stay at Southend. It was reported in the press that Princess Caroline had gone there for the summer season and had arrived with her suite on the night of Sunday 13 May. Princes Caroline was met at Rayleigh by Captain Asplin and his troop who escorted her to Southend and on to the Grand Terrace. On arrival at the Terrace, she was received by the Prittlewell Volunteers. The princess thanked all concerned but declined Captain Mill's order of a guard to accompany her during her stay. However, state archive papers show Princess Caroline was actually at Southend before 13 May and on

several occasions dined at William Whale's Ship Tavern. This is evidenced by a copy of a bill first dated 24 April 1804. On the bill for that day fish and sauce was served, as was rump steak, bread pudding and cheese. There was also beer, wine and sherry. On 4 May she must have had company as dinner was served for six. The princess was also billed for the hiring of a chaise to go to Billericay on 9 May and another to take her to Tilbury on 12 May. It is not known where she stayed during her first Southend visit. However, on her return from Tilbury she occupied properties at Nos 8 and 9 on the Terrace. Finding herself a little short of room, she later acquired the second-floor drawing room of No. 7. Her first glimpse of the Terrace, however, is likely to have been on Friday 3 April 1795 when she reached the Thames Estuary on her way to meet Prince George for the first time. She was on board the *Jupiter* which anchored at the Nore at 6 p.m. The *Jupiter* left for Gravesend at 9 a.m. the following day where, on Sunday, Caroline was transferred to the royal yacht which was to take her to Greenwich.

However, during her second 1804 visit to Southend the princess was feeling poorly at the end of May. Admiral Bartholomew Samuel Rowley (1764–1811), who was the then Commander-in-Chief at the Nore and based on the sixty-four-gun *Zealand* captained by William Mitchell, heard about Princes Caroline's condition. Rowley sent Dr Kent of the Sussex hospital ship at Sheerness over to Southend to attend to her. The princes speedily recovered and had several visitors to the Terrace during her Southend stay. One visitor was Captain Thomas Manby (1769–1834) who was introduced to her at Montague House in

Princess Caroline stayed at the Terrace in 1804. Lady Hamilton was there in 1805, accompanied by three of Admiral Nelson's nieces, his daughter, and the opera singer Mrs Billington.

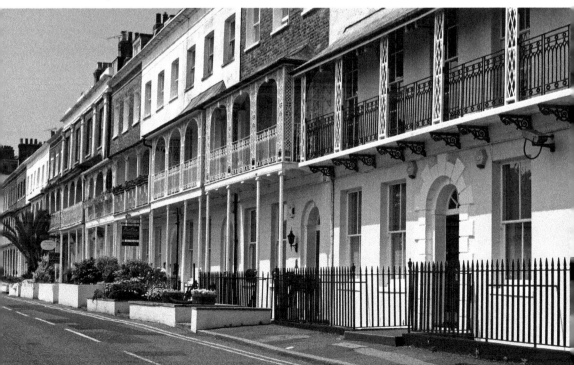

Blackheath by Lady Anne Townshend (Montgomery), who was Mistress of the Robes (1795–1820) to the princess. Thomas' father, Matthew Pepper Manby, had been an aide de camp to Anne's husband, Lord George Townsend (1724–1807). Thomas Manby was captain of the frigate *Africaine*, formerly the French *L'Africaine*, a frigate that was captured by the British in the Mediterranean on 19 February 1801. Manby was at the Nore with the *Africaine* for around six weeks, frequently visiting the princess at Southend. Princess Caroline and Thomas Manby were accused of having an affair, which both vehemently denied. After a lengthy and extensive enquiry, the malicious notion of such an inappropriate liaison was dismissed.

On Monday 30 July, Princess Caroline left the Terrace to board the *Chatham*, the yacht of Sir George Grey (1767–1828), commissioner of Sheerness from 1804 to 1806. This same yacht was used to transfer Nelson's coffin from HMS *Victory* at the Nore to Greenwich Hospital where he lay in state until his transfer to Whitehall for the state funeral. Grey, incidentally, was married to Mary Whitbread, the daughter of the brewer Samuel Whitbread (1720–96) by his second wife, Lady Cornwallis (1736–70). Princess Caroline was accompanied on the yacht by Miss Fitzgerald and Sir Thomas Maryon Wilson, 7th Baronet, whose sister Jane married Spencer Percival (1762–1812), Britain's only assassinated prime minister. Thomas' son, also named Thomas Maryon Wilson, the 8th Baronet, was born at Southend. According to the *Oracle Advertiser* of Thursday 2 August 1804, they all sat down to 'an elegant dinner' and 'in the evening there was a ball on the quarter deck in which Her Royal Highness took an active part and occasionally danced with commissioner Grey and Admiral Rowley'. There is no mention of Captain Manby in the newspaper piece, but he was there and is likely to have also danced with his friend Princess Caroline. The princess returned to Southend at around 2 a.m.

Captain Thomas Manby, incidentally, married Judith Hammond of Northwold in 1810 and the couple had two daughters, Mary and Georgiana. He was later promoted to Rear Admiral of the White. By 1833, his health began to deteriorate and his eyesight began to fail him. He died from an overdose of opium at the George Hotel in Southampton on 13 June 1834 and is buried at Stoneham. Judith died the following year and was interred at the same place.

The princess left Southend in October 1804. There is a plaque on the Royal Terrace commemorating Princess Caroline's stay, and, of course, it is due to her time spent at the Grand Terrace that it later acquired the name of Royal Terrace. After Caroline's death her coffin passed through the Essex towns of Romford, Chelmsford, and Colchester where it stayed overnight before journeying to the Port of Harwich. She is buried at Brunswick Cathedral. Caroline Amelia Elizabeth, an early nineteenth-century holidaymaker at Southend, was the Queen Consort of the United Kingdom from late January 1820 until early August 1821.

Dame Emma Hamilton and Friends

Emma Hamilton

Emma Hamilton was of humble origins. Born on 26 April 1765 near Neston, Cheshire, she was baptised Amy Lyons during the following month. Her father was a blacksmith who died when Emma was only two months old, so she was raised by her mother and grandmother. At around 1777 Emma (also known as Emma Hart) moved to London and later became a maid to Dr Budd and his family at Chatham Place, Blackfriars. At the Budd's household Emma shared a room with another maid who was a few years older than her. The maid was the future star actress Jane Powell. Emma became an actress too, a dancer and a model, posing for the artist George Romney (1734–1802). She is said to have developed several monogamous relationships with the men she met, but on 7 September 1791 Emma married Sir William Hamilton (1730–1803) who was serving as the British ambassador to Naples (from 1764 to 1800) and Emma, now Lady Hamilton, accompanied him there. At Naples Lady Hamilton befriended Queen Maria Carolina (Maria Carolina Luise Josepha Johanna Antonia, 1752–1814), the sister of Marie Antoinette (Marie Antoinette Josephe Jeanne, 1755–93), the last Queen of France, who was beheaded by the guillotine. It was at Naples where Lady Hamilton met Horatio Nelson and began a friendship that flourished until Nelson's death at the Battle of Trafalgar in 1805. In 1800, Lady Hamilton was awarded the Order of St John of Jerusalem for her services to the Island of Malta and so received a title in her own right, as well as that afforded to her on marriage to Sir William. She was therefore Dame Emma Hamilton when she visited Southend, but she continued to be affectionately addressed as Lady Hamilton.

Lady Hamilton had visited Southend on more than one occasion during the first decade of the nineteenth century where she enjoyed the bathing and thought it beneficial to her health. She was there in 1803 – two months after the death of Sir William. This is evidenced by a copy of a letter sent to her by Nelson and

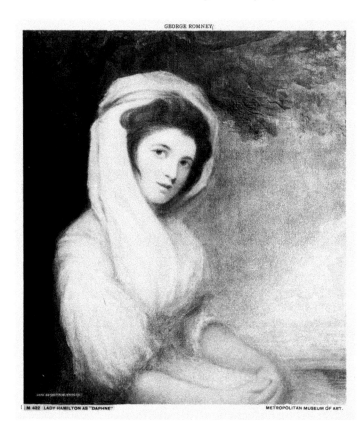

GEORGE ROMNEY

M 432 LADY HAMILTON AS "DAPHNE" METROPOLITAN MUSEUM OF ART.

Lady Hamilton as Daphne, painted by George Romney. (Courtesy of the Library of Congress)

published in *Memoirs of the Life of Vice-Admiral Lord Viscount Nelson* by Thomas Joseph Pettigrew (1849). The letter was written from the *Victory*, moored off Toulon, on 5 October:

> I was made truly happy by hearing that my dearest Emma was at Southend and well, and last night I had the happiness of receiving your letters of June 26th from Hilborough and of August 3rd from Southend and most sincerely do I thank God that it has been of so much service to your general health.

Lady Hamilton was again staying at Southend in 1805 when accompanied by Nelson's daughter, Horatia (Horatia Nelson Thompson). Also there was Nelson's niece, Charlotte Mary Nelson (later 3rd Duchess of Bronte), who in 1810 married Samuel Hood, 2nd Baron Bridport; and two nieces with the surname of Bolton, daughters of Nelson's sister, Susannah. They all stayed at number seven on the Terrace (now Royal Terrace), one of the properties occupied by Caroline, Princess of Wales, during the 1804 summer season. By the end of July Lady Hamilton had been in Southend for over a week and had planned to stay much longer. Also staying at No. 7 was Mrs Billington, a lady who was considered England's finest opera singer at the time.

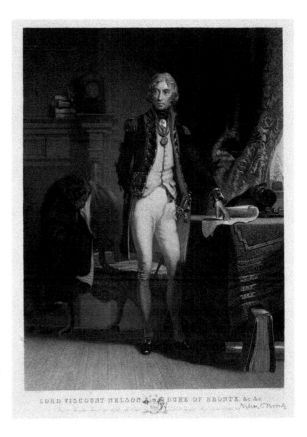

LORD VISCOUNT NELSON, DUKE OF BRONTE, &c.&c.

Lord Viscount Nelson, Duke of Bronte. In 1805 Lady Hamilton stayed at the Terrace with Nelson's daughter and three of his nieces. (Courtesy of the Library of Congress)

On 12 August, Elizabeth Billington and Lady Hamilton visited Southend's first theatre. It was opened in 1804 and managed by the London-born Thomas Trotter, the proprietor of several provincial theatres from which he made his fortune. Lady Hamilton and Elizabeth were entertained with *Night Inkle*, *Yarico*, *Lovers Querrels* and *Who's the Dupe*. The two women later invited Infant Roscius (a young comic entertainer) to have dinner with them. They also visited a marquee at one of the signal stations where Lady Hamilton and Elizabeth gave Infant Roscius complimentary souvenirs.

However, on the evening of 18 August Lady Hamilton received correspondence to say Nelson was returning to England. At 5 a.m. the following day Lady Hamilton, Charlotte and Horatia climbed into a chaise, leaving Southend for Merton where Lady Hamilton and Nelson had their new home. Less than three hours later, at 7.45 a.m., Nelson was back on English soil. On 20 August, the young Bolton ladies received a letter from Lady Hamilton to say she was giving up her house on the Terrace and so Susannah's daughters packed their bags and set off immediately to join her and meet their uncle.

Mrs Billington was going to leave too. Her next singing performance was at Cheltenham, but that was not for another two weeks, so after some thought she decided to stay at Southend for another ten days and took up lodgings at the beach.

Southend inhabitants and visitors to the town were disappointed Lady Hamilton had gone; she was surely missed. The following appeared in the *British Press* on 29 August: 'Southend had better be called Gravesend from the dullness of the place since the disappearance of Lady Hamilton.'

Her good friend Jane Powell, who by this time was at Southend, wrote to her:

> I cannot forbear writing a line to inform your ladyship I am at this place, and to tell you how much your absence is regretted by all ranks of people. Would to Heaven you were here to enliven this (at present) dull scene. I have performed one night, and have promised to play six, but unless the houses are better must decline it. Please to remember me most kindly to your mother and everyone at Merton.

It would appear the size of the audience increased on subsequent nights as Jane returned to Southend in 1806 during the spring and again in the autumn.

Lady Hamilton, however, does not appear to have visited Southend again. She held a ball at the Royal Hotel in honour of Nelson on 20 August, but she was at Merton, not Southend. In her absence the turnout was disappointing. No doubt the heavy rain also had a part to play in reducing the numbers present. Dancing, however, still continued until 3 a.m. One lady in attendance was Lady Harvey (Nugent) whose husband, Sir Eliab Harvey, two months later commanded the *Temeraire* at the Battle of Trafalgar. Dame Emma Hamilton died at Calais on 15 January 1815.

Jane Powell

Jane Powell was the daughter of an army sergeant and is said to have been born in 1761 at Cranbrook in Kent. Her mother died a few hours after her birth so, like Emma Hamilton, she lost a parent at a very early age. Jane aspired to become an actress after seeing the *Grecian Dancer* and was no doubt encouraged to enter that profession by her dear friend Emma. Her first acting performance was at the Haymarket Theatre on 29 August 1787. Under the supposed assumed name of Mrs Farmer she played Alicia in *Jane Shore,* a play based on Nicholas Rowe's a *Tragedy of Jane Shore* (1714). Mrs Farmer again played the part of Alicia at the same theatre on 9 September 1788 and on 25 November the same year she performed as Anne Bullen in *King Henry the Eighth* at the Drury Lane Theatre where she became a favourite actress of the fee-paying public and was offered a permanent position, which she gladly accepted. Jane many times played alongside Sarah Siddons (1755–1831), that master of tragedy, best known for her outstanding performances of Shakespeare's Lady Macbeth. Jane must have learned a lot from her, for in later years she was often compared to that fine actress who was second to none.

However, Jane was later engaged on the Liverpool circuit where she met the comedian and prompter William Powell. The two fell in love and were married by licence on 20 August 1789 at St Peter's in Church Street, Liverpool. Contemporary and some later writings state this was her first marriage, but the church records clearly show she was Jane Farmer, a widow, so the marriage to William was her second, and Farmer was her married name, not an assumed one. In 1805, the then Mrs Powell came to Southend where her friend Emma Hamilton was staying. Jane agreed to perform for six nights at Trotter's Southend Theatre as we have seen from her letter to Emma. On 3 September 1806, Jane was back in Southend, playing Millwood in the *Tragedy of George Barnwell*, and was booked to perform there for a further three nights. Lady Charlotte Denys of Bow-Window House (until recently a part of Sunspot Amusements but now Circus Amusements) at the bottom of Pier Hill was in the audience, as was another lady of title, Lady Caroline Alicia Brisco. Lady Brisco (Fleming), whose portrait was painted by Thomas Gainsborough and is now part of the Kenwood House (Hampstead) art collection, was staying at the Terrace, occupying No. 7 as Lady Hamilton had done the previous year. She was the daughter of Gilbert Fane Fleming, the Lieutenant Governor of St Kitts and the Lieutenant-General of the Leeward Islands. From him Lady Brisco had inherited plantations and slaves during those shameful days of British history.

Jane's September performances, however, appear to have been her last at Southend and it was probably after these appearances that she separated from her husband, William, who died on 26 May 1812. At the time of his death,

Lady Charlotte Denys, who lived at Bow Window House, now a part of Circus Amusements, was in the audience to watch Jane Powell perform at Trotter's Theatre. Bow Window House is the building on the right with the lower roof above the 'Roll Up' sign.

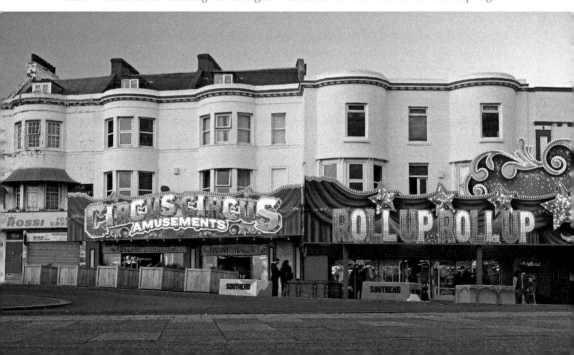

he was the proprietor of the Lyceum Theatre and for over twenty-five years the proprietor of the Drury-Lane Company. Jane later married John James Renaud, a Scottish Provincial actor. They were married on 31 January 1813 at St George's, Bloomsbury, in London. The couple went to Edinburgh where Jane performed in the presence of George IV. Unusually, the king bowed when he saw her. It was rumoured she was once his mistress. Jane's last performance was at Edinburgh on 30 September 1829 when she played the queen in Hamlet. She became estranged from her third husband and she died in near poverty on 6 January 1832.

Elizabeth Billington

Elizabeth Billington was born at Litchfield Street on 27 December 1765 and was baptised at St Anne's, Soho, the following month. She was the daughter of Charles Weichsel, a travelling musician, and Frederica, who was a regular singer at Vaux Hall Gardens from around 1763 until her death in 1786. Before Elizabeth's marriage to James Billington at St Mary's, Lambeth, on 13 October 1783, her parents had apparently separated due to Charles' bad temper. Elizabeth disowned her father and used her mother's maiden name of Wierman when marrying James. The newly married couple made several trips to Dublin where Elizabeth performed in public. In 1788, she performed with great success as Rosetta in *Love in a Village* at Covent Garden. In 1794, she went to Naples, Italy, where she met Sir William Hamilton and Lady Emma Hamilton, who introduced her to the queen, in front of whom she performed. This led to her receiving an invitation to sing at San Carlo in a new opera *Inez di Castro*. Elizabeth also performed in Milan where she was received by the Empress Josephine. It was at Milan, after the death of James, that she met her second husband, a young Frenchman, Monsieur Felissent. They were married in 1799 and went to live at St Artien, near Venice. Elizabeth left her second husband in 1801, however, and came back to England. In May 1805, there was a fire at her Cadogan Place home which disturbed her and so she sought comfort with her friend Lady Hamilton. In July she accompanied Lady Hamilton and Horatia to Southend. Although the then prima donna stayed for several weeks in Southend it does not appear she actually performed there. She visited Trotter's theatre on several occasions, however, and would watch performances from one of the boxes.

Elizabeth was reunited with her husband in 1811 and returned to St Artien where she died on 25 August 1818. She was, incidentally, depicted as St Cecilia, the patron of music, in a painting by Sir Joshua Reynolds (1723–92), a founder of the Royal Academy and its first president.

Although Southend was still considered to be a small watering place at the end of the Georgian period, it had no problem in attracting the famous people of the

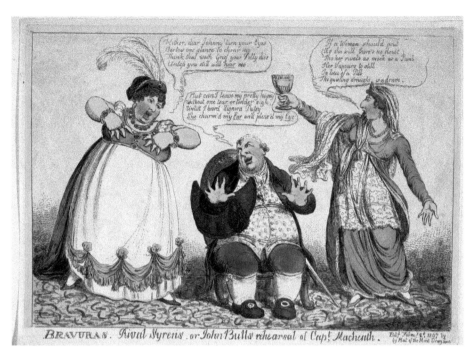

A cartoon of rival sirens: Elizabeth Billington (left) and Catalani. (Courtesy of the Library of Congress)

day, who in some cases chose to spend the summer season there. No doubt that during those early years the lively personality of the blacksmith's daughter played its part in popularising Southend – perhaps more so than Dame Emma Hamilton has ever been given credit for. She helped the local economy by spending freely in the local shops and introduced others to the town. There is no memorial to her at Southend. No. 7 Royal Terrace, however, is named 'Hamilton House'.

The Arts

Trotter's Theatre and the Austen Connection to Southend

Southend's first purpose-built theatre was near the Castle Inn. It was opened in 1804 by the London-born Thomas Trotter who attracted some of the top performers of the day. He also offered a position to the then low-status comedian and actor William Oxberry (1784–1824). William sometimes performed with the actress Catherine Elizabeth Hewitt, who mainly played minor parts at Southend and at other theatres on Trotter's circuit. On Monday 6 October 1806, William performed at Southend in *The Wonder, A Women Keeps A Secret*, a comedy performed for the benefit of Mr Trotter. William played Lissardo, Catherine played Ines, Thomas Trotter played Don Felix, and Margaret Trotter played Violante. William also played in tragedy at Southend, performing as Hassan, Shylock and Orozembo, so it is possible he acted alongside Jane Powell. However, love blossomed between William and Catherine, and they married in 1806 at the parish church of St Mary, Prittlewell. William died in 1824 and during the same year as his demise the widowed Southend actress married another actor, Leman Thomas Tertius Rede (1799–1832) at St James' Church, Clerkenwell, Islington. His brother was the playwright William Leman Rede (1802–1847); his sister was the novelist and feminist Mary Grimstone (1796–1869).

On 20 July 1807, Thomas Trotter married Margaret Kline. Their wedding took place at the church of St Clement Danes in Westminster, London. Thereafter, Thomas and Margaret appear to have spent most of their time at Worthing in Sussex where Thomas opened a theatre in Anne Street. He would appoint a manager to each of his other theatres in his absence. The manager at Southend was the actor Mr Brew. Brew was succeeded by Samuel Jerrold who leased the Southend theatre from Trotter after successfully applying for a licence in 1811. Jerrold was previously the lease holder of the theatre at Sheerness, which he acquired in 1807.

Samuel Jerrold, by his second wife (Mary Reid) whom he married at Wirksworth on 20 April 1794, was the father of the playwright and journalist Douglas

William Jerrold (1803–57), who became a close friend of the novelist Charles John Huffam Dickens (1812–70). Douglas had performed in minor parts at the Southend theatre, but mainly at Sheerness. At the age of eleven he entered the navy on the recommendation of Captain Charles John Austen, later a Rear Admiral of the Blue, and the younger brother of the novelist Jane Austen. Captain Austen was the flagship captain of the *Namur*, which was the guardship of the Nore. He was assigned to the *Namur* by his friend and patron Sir Thomas Williams, who at the time was the Commander-in-Chief, a position once held by Nelson. Charles Austen served at the Nore from 20 November 1811 to 30 November 1814. Sir Thomas Williams' first wife, incidentally, died in a carriage accident in 1798. She was Jane Cooper, a cousin of Austen.

Douglas Jerrold, however, was appointed midshipman on Captain Austen's seventy-four-gun man-of-war. Austen was no doubt sympathetic to the arts, allowing Douglas to spend time in his cabin reading books. He also allowed Douglas to keep pigeons on board. It was on the *Namur* that Douglas met the artist Clarkson Stansfield (1793–1867), who was another close friend of Dickens. Douglas and Clarkson worked together, arranging and participating in theatrical productions on board the ship. Clarkson used his talents to paint the scenery for their performances.

However, Thomas Trotter was at one time a lessee of the Theatre Royal in Brighton and in 1814 he received a gift of £25 for the theatre from the Prince Regent. Thomas retired in 1826 at which time his theatres at Southend, Gravesend, Worthing and Hythe were put up for sale by Messrs Robins at Covent Gardens. The Southend theatre, a copyhold property, was sold for £720. Thomas died at Worthing in 1851 and Margaret at Lewes, Sussex, in 1856. He is buried at Gravesend, as is Margaret.

Jane Austen (1775–1817)

Another visitor to Southend during those early years was John Grove Palmer, who was the attorney and advocate general on the island of Bermuda from 1783 to 1801. One of his daughters, Frances Fitzwilliams Palmer, who was born in Bermuda, married Captain Charles John Austen in 1807. In 1812 and 1813, the Palmers chose to holiday at Southend, which gave them the opportunity to see their daughter who usually lived aboard ship with her husband. It was a good opportunity for Frances to spend time on shore with her family, and Charles could easily cross the Thames to visit his wife and in-laws when on leave. Frances' sister Harriet was also there. Charles married Harriet after Frances died.

Frances' sister-in-law Jane Austen never actually visited Southend, but she mentions the place in her novel *Emma*: Mr Wingfield recommended a visit to Southend for the health benefits of the sea air and bathing.

It is likely Jane learned a lot about Southend from Frances, and their conversations may have influenced Jane's writing. Certainly, it is possible to draw parallels between Southend and Sanditon, a growing watering place in Jane's unfinished novel. Sanditon is on the Sussex coast and, like Southend, it has new buildings. Jane mentions 'a brow of a steep but very lofty cliff' and 'a short row of smart-looking houses called a Terrace, with a broad walk in front, aspiring to be the Mall of the place'. She continues: 'In this row were the best Milliner's shop and library a little detached from it, the hotel and billiard room. Here began the descent to the beach and to the bathing machines. And this was therefore the favourite spot for beauty and fashion.'

Herbert George Wells (1866–1946)

Southend even got a mention by the novelist H. G. Wells in his *War of the Worlds*, a semi-documentary-style novel about an attack on humanity by visiting occupants of the planet Mars. The narrator speaks of not only the road that goes through Barnet '…but also through Edgware and Waltham Abbey, and along the roads eastward to Southend and Shoeburyness'. As sailors were unable to come up the Thames with their passengers '…they came onto the Essex coast, to Harwich, and Walton and Clacton, and afterwards to Foulness and Shoebury to bring people off'. One steamboat full of passengers was just off the Blackwater,

Artwork with a space theme on a concrete wall next to a twin experimental casement at Gunners Park, Shoeburyness.

when, at 5 p.m., gunfire was heard in the south. 'Some of the passengers were of the opinion that this firing came from Shoeburyness, until it was noticed it was growing louder.'

New Tricks

In Series 4 of the television drama *New Tricks*, released in 2007, the veteran detectives of the Unsolved Crimes and Open Case Squad (UCOS) set out to solve the case of June Parker's father, who was one of the last men to be hanged in Britain. Gerry Standing (Dennis Waterman 1948–2022) visits Miss Parker's home to question her. While there Gerry notices an old picture of Southend Kursaal on the wall, showing the main entrance to the 'Kursaal and Gardens' and on the left of the picture is the 'Kinema'. June Parker (Jan Francis) says that her 'idea of a big treat was a candyfloss on the pier'. In another clip Gerry says: 'Imagine Southend pier, one of the wonders of the world. It stretches so far out to sea you need a train to get you there and back.' June adds that she had a beach hut at Shoeburyness.

New Tricks is frequently shown on the Drama TV channel, which, before some programmes, shows a clip of a man standing on a breakwater near the old Crowstone at Chalkwell.

Southend Pier 'stretches so far out to sea you need a train to get you there and back,' says Gerry Standing in the TV drama *New Tricks*.

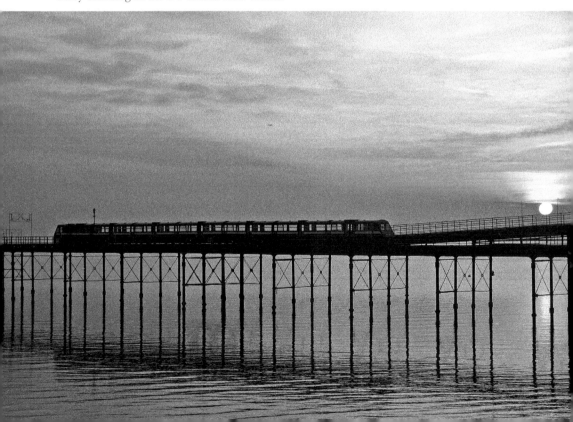

Goldfinger

Southend is generally a friendly place, but it has attracted at least one nasty villain whose chief aim was to seriously damage the world economy by destroying all the gold at Fort Knox in Kentucky, USA. It was in the early 1960s when Auric Goldfinger boarded a British United Air Ferries Carvair (G A5DC), flight number CF400, from Southend. It was bound for Geneva in Switzerland. Goldfinger was accompanied by his henchman who went by the name of Odd Job. Tracking the pair was the British agent James Bond, designated 007.

The film *Goldfinger* had its premiere at Leicester Square, London, in 1964. Bond was played by Sean Connery (1930–2020) and he can be seen in the film at Southend Airport sitting in his Aston Martin DB5. Bond caught the next flight which left Southend thirty minutes after flight CF400. Goldfinger was played by Gert Frobe (1913–88) and Odd Job by Harold Toshiyuki Sakata (1920–82). Harold won a silver medal as a weightlifter at the 1948 London Olympics. He later turned to wrestling where he performed under the name of Tosh Togo.

James Abbot McNeill Whistler (1834-1903)

The American-born painter James Whistler may not be as famous as Joseph Mallord William Turner (1775–1851) who painted the *Shoeburyness Fisherman Hailing a Whitstable Hoy*, but he was a very well-known artist of his day. In 1881,

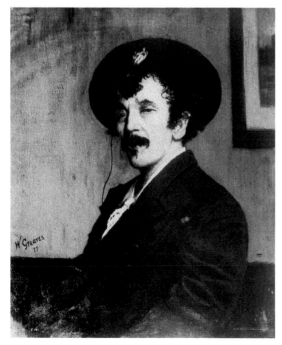

James Abbott McNeill Whistler. (Courtesy of the Library of Congress)

Princess Louise visited his London exhibition of Venice pastels at the Fine Arts Society. He is also one of the last people she visited before her journey to Canada. It is probably true to say, however, that with the possible exception of a painting of his mother, his most famous paintings were of his friend, lover and assistant Joanna Hiffernan – *Woman in White*.

James was born at Lowell, Massachusetts, where his father, George Washington Whistler (1800–49), was an engineer on the Middlesex Canal. George was later employed by Czar Nicholas I to build the Moscow to St Petersburg railway. George's father, John Whistler, was born in Northern Ireland and joined the British Army, and later the United States Army. He supervised the building of forts, including Fort Dearborn where the city of Chicago now stands. John and George had both attended West Point, the United States Military Academy, and had reached the rank of major during their careers. James Whistler was also at West Point, but he took a different career path by becoming an artist. James painted scenes of the Thames, including an oil on canvas at Wapping and another at Battersea Reach. The Smithsonian Freer Gallery of Art in the United States of America, however, holds four of his paintings done at Southend: *Southend Pier*; *Southend, the Pleasure Yacht*; *Southend Sunset*; *Grey and Silver Pier – Southend*.

It is not known for sure when James visited Southend, but it was most likely in the early 1880s – probably 1882 or 1883. Certainly, *Southend Pier* was painted

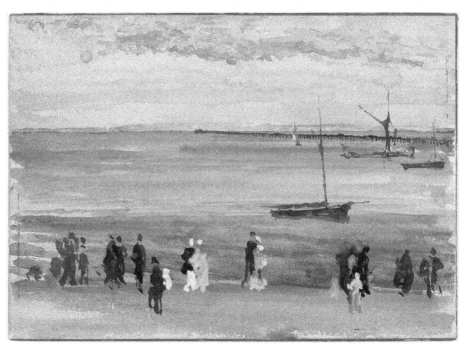

Southend Pier by James Whistler: a watercolour painting of people at the water's edge with the old wooden pier in the background. (Courtesy of the Freer Gallery of Art)

before 1884 as on 13 May that year he exhibited a painting of that name at Messrs Dowdeswells in Bond Street, London. *Southend Pier* does not appear to have been exhibited before that date.

In 1934 and 1940, James Whistler was posthumously honoured by the US postal authorities. His painting of his mother is on the 1934, 3 cents, Mother's Day stamp. James Whistler's portrait is on another stamp: the 1940, 2 cents commemorating artists.

George Davison (1854–1930)

George Davison was a keen amateur photographer who founded the Linked Ring Club and he became a director of Kodak in 1900. On 13 May 1896, he exhibited a photograph taken at Southend in the Photo Club Exhibition on the Galerie des Champs-Élysées in Paris. His photograph was of Southend Pier at night. In the opinion of the correspondent writing for the *Glasgow Herald* of 15 May, the photograph was considered to have Whistleresque effects: 'The lights on the jetty blink weirdly against the sombre black of pier buildings, the latter nearly lost in the blackness of night.'

Transport

The Railway

It is probably true to say that very few people, if any, would risk travelling the roads from London to Southend by horse and chaise as some did in the early nineteenth century. The preferred method of transport today would be to travel along the motorway by car or to journey by train on one of the two rail routes into the city. Rail travel to Southend from London was made possible by the opening of the London, Tilbury & Southend (LTS) railway line which was built during the 1850s and covered 36.5 miles to Southend. For passengers leaving Fenchurch Street, however, an additional 5.5 miles of track of the Blackwall line had to be used before joining the LTS, and the same length of track of the Eastern Counties line was used on leaving Shoreditch. The LTS line was open to passengers as far as Leigh on 1 July 1855; omnibuses were available to transport passengers wanting to travel the additional 3 miles to Southend. The railway line to Southend itself was open to the public on 1 January 1856, although this was only a single track at the time. The line was later extended to Shoeburyness, which was open to public traffic on 1 February 1884. All through trains would then wait for five minutes at Southend (now Southend Central) before continuing their journey in either direction. A new station was opened at Westcliff in 1895 and was then named Westcliff-on-Sea. A new service of five trains each weekday from St Pancras in London to Westcliff-on-Sea and Southend was introduced shortly after. In July 1910, a new station between Southend Central and Shoeburyness was opened. This was Southchurch-on-Sea, which was renamed Thorpe Bay. Another station, Southend East, was first opened in 1932. At the same time, on the west side of Southend Central, a new station was being built at Leigh to replace the Old Leigh station, which closed in 1934. Chalkwell station was opened on 11 September 1933.

In 1889, a second railway arrived, with Southend Victoria station opening on 1 October. The first train bound for London left Southend Victoria at 7.13 a.m. on that day with ninety-two tickets sold for journeys to various stations along the line, but only one passenger travelled the whole journey to London. At the

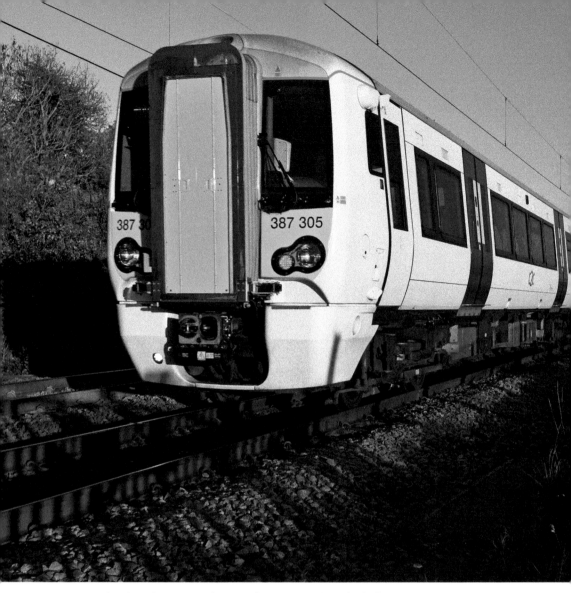

A Bombardier Electrostar Class 387 between Leigh and Chalkwell.

time the line was only single track from Prittlewell to Wickford Junction, with passing loops at Rochford, Hockley and Rayleigh. The line was doubled between Prittlewell and Rochford in 1896, with the first passenger train using the new track on Sunday 1 March.

The Liverpool Street to Southend Victoria line is now served by the new five-carriage, Class 720 Aventra trains made by Bombardier, the first two of which were introduced to the line on 26 November 2020. The carriages are walk-through without any first-class compartments and are the first in the UK to have underfloor heating. Two five-carriage sets may be coupled together to form a ten-carriage train during busy periods. C2C may also be running the Class 720 trains by the time this book is published.

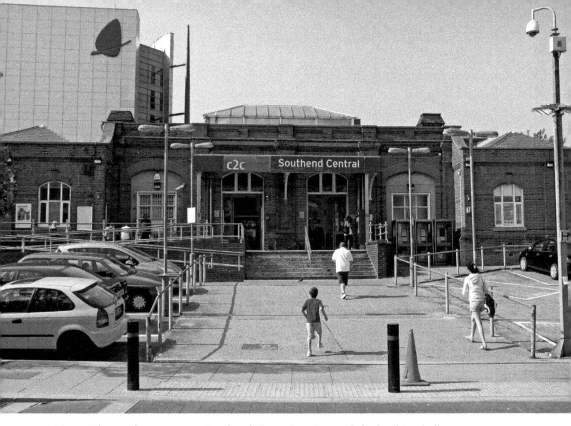

Above: The south entrance to Southend Central station and the booking hall.

Below: Southend Victoria station.

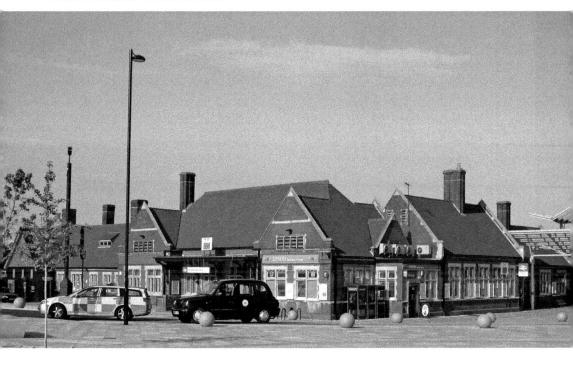

Route 68

Since before the First World War Southend sightseers have been able to enjoy travel along Southend seafront on an open-top vehicle. During some years the route was from Shoeburyness to Leigh, but for most years the journey to Leigh was from the Kursaal. The present route takes in Southend Pier, Westcliff, and Chalkwell, before making its way to Marine Parade at Leigh and then on to Leigh Broadway. Passengers for Old Leigh need to leave the bus at The Ship and then walk over the railway bridge.

One of the buses used on the route is an Alexander Dennis DD34, a prototype test vehicle for the popular Enviro 500. It was converted to the open-top Ensignbus 368 by Ensign of Purfleet, a company formed in 1972 that was was sold to First Group in 2023.

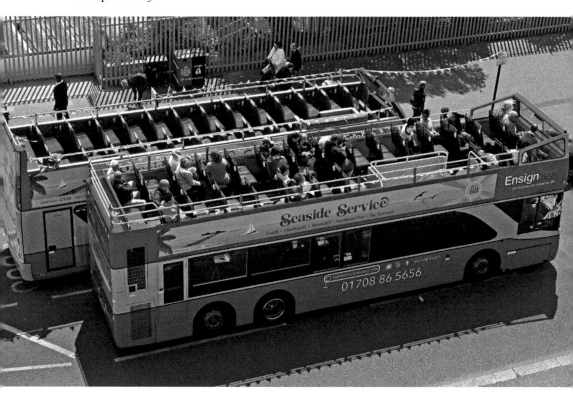

The bus in the foreground, which operates on Route 68, is a prototype Enviro 500 converted to open top by Ensign and carries the registration number EB68.

Aviation and the London Southend Airport

Before the First World War

In 1909, the Wembley Park Syndicate desired to hold an aviation meeting on their own grounds which was to include a match between the French aviators Arthur Charles Hubert Latham (1883–1912) and Louis Charles Joseph Bleriot (1872–1936). Bleriot walked the field and noticed a high mound on one side. He had no objection to flying there, but he saw the mound as an obstacle that would not allow him and Latham to safely use their skills to the full in a match with a prize of £4,000 to the winner and £1,000 to the loser. Ealing and Southend were asked if they would hold the aviation meeting instead. Ealing declined. However, Southend's mayor, James Colbert Ingram, embraced the idea and he had in mind using land adjoining the Great Eastern Railway at Prittlewell. Ingram said he would put the idea forward at a future town meeting. That simple request, and Ingram's response, appears to have been the catalyst for bringing aviation to Southend and the later building of a municipal airport.

In April 1910, at the annual meeting of the Swimming Club, a Mr Swainson read a letter that he received from Baron Von Reiffenstein who was a chief proponent of an aviation meeting in the Southend area. The baron's letter indicated progress had been made in bringing the aviation dream to the town and that it was highly likely Southend would be able to hold a ten-day aviation event in September. Such an event was approved by attendees at a town meeting held on Friday 27 May. At the meeting Earl's Hall was considered a possible site for the event. Another place considered was land at Southchurch held by Lieutenant-Colonel Edward James Newitt who, incidentally, was a Southend councillor for around fifteen years and who formed the 1st Battalion of the National Guard a few years later at the start of the First World War. However, the meeting and its outcome were not endorsed by the corporation, or the mayor, who did not attend. This was due to the fact that the town's people were required to make a financial contribution to what would primarily be a commercial concern. The Aero Club, which was formed in

1901 and became the Royal Aero Club in 1910, governed aviation events and had agreed, in principle, to a date for an aviation meeting to be held at Southend from 15 September or thereabouts, but later withdrew its support.

On the evening of Wednesday 6 July 1910, the pioneer aviator George Arthur Barnes (1883–1919) had permission to stage a flying exhibition at the ground of Southend Football Club. Barnes had visited Southend before, in April 1901, when he successfully competed in cycle races, achieving two firsts and a second. It would appear Barnes liked to live in the fast lane, graduating from bicycles to motorbikes (which he sold and manufactured) and then on to aeroplanes. Thousands of people are said to have watched his flying demonstrations at the football ground, no doubt igniting their imagination. Unfortunately, the country was at war a few years later.

After the First World War

When the First World War broke out the land adjacent to the Great Eastern Railway at Prittlewell, which is likely to have been the same ground Mayor Ingram had in mind for the aviation match, was used by the military as a training ground for flyers. It soon became used for air defence against German Zeppelins and, to a lesser extent, the twin-engine Gotha bombers. The airfield was operated by the Royal Flying Corps (RFC), except for a short period when the Royal Naval Air Services took command.

One of the pilots operating from Rochford was Henry Clifford Stroud, the son of Dr Henry Stroud, Professor of Physics at Armstrong College, Newcastle. Henry was in the Royal Engineers (territorials) but attached to the Royal Flying Core. On the moonless night of 7 March 1918 he set off from the Rochford airfield in pursuit of a German aircraft, as did a pilot from another airfield. The two aircraft collided with each other, killing the two pilots. There is a memorial tablet at St Andrew's Church, Rochford, which was unveiled in September 1921 by James Inskip, the second Bishop of Barking and previously a vicar at Jesmond, Newcastle. Rail travellers on the Southend to Liverpool Street line, however, may be more familiar with the propeller memorial, which was on the north side of the railway track between Wickford and Rayleigh. The memorial, which is not there at the time of writing, marked the spot where Henry Stroud's aircraft hit the ground. According to *The Newcastle Daily Chronicle* dated 24 September 1921 the original memorial was 'marked by his squadron by means of an inscription on a propellor, as sacred to his memory. A sun dial has recently been set-up at the spot'. After the war the RFC moved out of the airfield and any unwanted items were sold.

On 24 November 1920, Offin and Rumsey, acting on behalf of the Ministry of Munitions under directions of the Disposal Board, held a sale of chairs, saucepans, pillows, curtains, tables, 552 headboards and more. In 1922, on 7 and 8 June, Wilber and Bullivant of Westcliff-on-Sea and Leigh auctioned the switchboard, generators,

electric motors, carpenter's benches, fitters benches and other items. With the buildings now empty it was time for them too to be sold, and the *Essex Chronical* of Friday 16 June 1922 reported that nearly £7,000 was realised from the sale. The timber huts fetched from £30 to £100. The timber hangers sold for £200 each and the corrugated-iron buildings were priced at £70 to £100. The officer's quarters went for £100. There was also a hostel and a hospital on the site, both of which were sold. After the buildings were removed the land appears to have been used for farming.

Incidentally, the Eastwoodbury Agricultural Training Centre, which opened next to the disused airfield in January 1919, was put up for sale on 5 and 6 October 1921 with 150 iron bedsteads in addition to miscellaneous items, including live and dead stock.

In 1929, however, the 4 July edition of the *Daily Mirror* published a photograph of the then mayor of Southend, Reginald Henry Thurlow-Baker, and his wife Alice Augusta, about to take a twenty-minute flight over the borough courtesy of Aeroplane Services Ltd. The caption states Thurlow-Baker took the flight after opening an aerodrome at Southend. It would therefore appear aircraft were back at the land once occupied by the RFC.

However, in 1931, *The News Chronicle* of Monday 10 August reported that Southend Flying Club had held its first air pageant at Rochford racecourse. This was the home of Southend Races, a course where horses under 15 hands (ponies) would compete. The track opened in August 1927. This is not the same Rochford track where Southend races were held under National Hunt Rules. That closed for the last time many years earlier, on 11 January 1848. The air pageant was attended by Southend's mayor, Albert Martin, who had bought a horse for his daughter Betsy, whom he and his wife had adopted shortly before his wife's death. Betsy was keen to ride her new horse, but the horse showed so much pace that Albert decided to enter it for races on the Rochford track. Concorde had several successes, including a dead heat, and a win in the Oxford Handicap which he won by ¾ of a length. Betsy, incidentally, who attended St Hilda's School in Southend, became Southend's youngest mayoress elect at the age of thirteen and the youngest mayoress at age fourteen. At the Southend Flying Club's air pageant, however, Mayor Albert Martin announced the Southend Corporation had set up a special committee to consider acquiring a site for a municipal airport.

The Municipal Airport Opens

On Tuesday 19 December 1933 Southend Corporation decided to purchase 157 acres of land adjacent to the railway line, which the *Essex Chronicle* reported would be at a cost of £20,000. On 18 September 1935 the Southend Municipal Airport was officially opened. In attendance was Mayor Allen Threlkeld Edwards and Sir Philip Albert Gustave David Sassoon, the under secretary of State for Air. Sir Philip Sassoon arrived in a three-seater monoplane, a De Havilland Leopard

Moth. He was accompanied by four biplane bombers, the two-seater RAF Hawker Hart. Sir Philip cut the tape between two posts through which an aircraft manoeuvred before take-off, officially opening the municipal airport.

In 1938, Southend, along with airfields at Bristol and Belfast, was added to the list of twenty-nine existing RAF voluntary reserve service centres. The period of service was for five years, and no previous flying experience was required for enrolment. The following year the airport was again requisitioned at the commencement of the Second World War. RAF Rochford, as it was firstly known, became RAF Southend and was a satellite to RAF Hornchurch. At the time the airfield had a grass surface within a perimeter track. At the end of the war the Royal Air Force moved out and the airfield reverted to a municipal airport with Southend Council back in control. Cross-channel services came to the fore and in 1949 the mayor and mayoress of Ostend landed at Southend, returning a visit the mayor and mayoress of Southend had made to Ostend the year before. New runways were installed during the 1950s and the airport continued to grow. Passengers travelling on the Liverpool Street to Southend railway line may recall seeing the Avro Vulcan XL426 there, which first arrived in 1986. In 1990, however, the council sold the airport to Region Airports Ltd and Esken took over in 2008. At the time rail passengers would have to leave the train at Rochford station and catch a taxi or bus to reach the airport. Such an inconvenience was overcome in 2011 with the opening of the new purpose-built London Southend Airport railway station. The new air traffic control tower was opened the same year and the Holiday Inn hotel at the airport opened in 2012. Flights were stopped in 2020 due to Covid-19. Flights have now resumed, however, and it is only a matter of time before the airport reaches (or exceeds) pre-pandemic levels.

Southend Airport was opened in 2011. On the right of the picture is the airport control tower, which was opened during the same year.

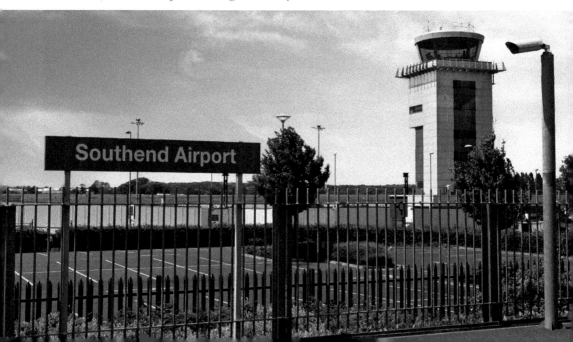

Public Open Spaces

The Spaces

The most obvious open spaces available to the general public within the 16 square miles of the city of Southend are its beaches from Leigh-on-Sea in the west to Shoeburyness in the east. Less known to the day-tripper, however, but familiar to local residents, is Southend's wealth of public parks, gardens and nature reserves. These cater for a variety of social groups, facilitate play and recreation, promote well-being, and benefit the local ecology and the environment. There is around 577 hectares of these public open spaces in Southend, of which the largest is Belfairs, amounting to 85 hectares.

Belfairs

The Belfairs planning initiative began over a century ago, in 1914, just before the start of the First World War, when Southend Town Council decided to purchase 270 acres of land at a cost of £16,500 for the laying out of a municipal golf course in addition to a separate area to be used for general recreational purposes. Everything appears to have been put on hold during the war years because in 1923 the council again approved the purchase of land but for the increased sum of £20,000. A further £10,000 was spent on the actual laying out of the golf course, which was designed by the golf architect Henry Shapland Colt (1869–1961) who, at the time, lived in Sunningdale, Berkshire. Colt was a keen golfer himself, having learned to play at St Andrews in Scotland, the home of the oldest golf course in the world. The new eighteen-hole golf course at Southend, however, was first played by members of the public on Saturday 4 September 1926, but was not officially opened until Mayor Herbert Arthur Dowsett, the son of Southend's first mayor, Thomas Dowsett, hit his first ball there on Saturday 11 September. The cost of a round of golf at the time was 18 pence, in pre-decimal coinage.

On 27 July 1934 it was stated in the *Essex Chronicle* that the Essex branch of the Council for the Preservation of Rural England was supporting the South Essex

Natural History Society's aim to turn Belfairs Great Wood into a nature reserve, but a stumbling block was that the area had been marked as residential on the Town Planning Act. By 1936 the area was priced at £20,000 with Essex County Council offering to contribute 20 per cent of the purchase price, with Benfleet Urban District Council contributing 10 per cent and £1,000 had been raised by the South Essex Natural History Society. Southend Council, however, on at least two occasions, refused to pay the remainder. On Tuesday 19 October 1937, when faced with a petition of more than 20,000 signatures, Southend agreed to pay their £7,669 share of £12,000 to secure the wood. A bird sanctuary was to be sited on 41 acres at a cost of £8,000, which was included in the total purchase price of £20,000. The Belfairs public open space has been added to over the years to reach its current size.

Gunners Park

The next largest area is Gunners Park at Shoeburyness on the east side of the borough, which amounts to some 34 hectares. The land was once home to the Shoebury Garrison and the Garrison School of Gunnery, so for many years was closed to the general public. Notable figures attending the Garrison School included Prince Arthur, the Imperial Prince (Prince Louis Napoleon Bonaparte) and the comedian Frankie Howerd, who made his name in the 1960s and 1970s by appearing in television shows for the BBC and others. He also appeared in films, including *Carry on Doctor* and *Up Pompeii*. Many of the old buildings of the Shoebury Garrison still stand, including the clock tower at Horseshoe Barracks, now a residential area.

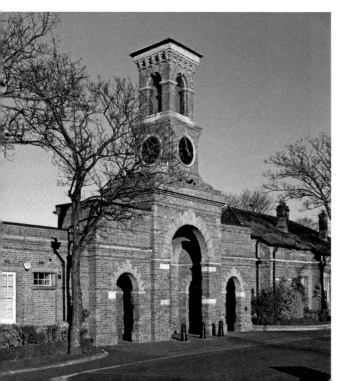

Gunners Park. The clock tower is at the entrance to Horseshoe Barracks, which is now a residential area.

The short Garrison Pier built in 1908–09 also survives, but this may not be accessed by unauthorised persons. The pier was used for the loading and unloading of weaponry and munitions for transport up the River Thames to Woolwich, or occasionally across the water to the mouth of the Medway and on to Chatham in Kent. The beach is not accessible to the public at this point, but sea anglers have enjoyed fishing from the nearby sea walls. There is a small lake in the park for the benefit of wildlife.

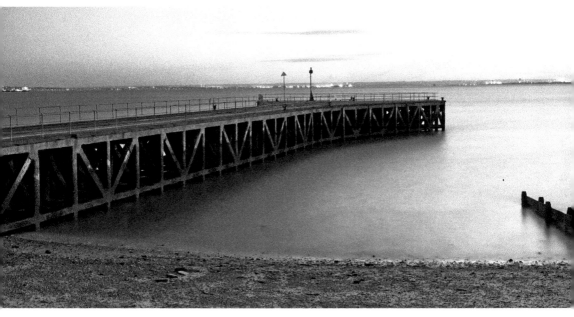

Above: The Garrison Pier at Gunners Park, which was built in 1908–09.

Below: Waiting for a bass. Two sea anglers at Gunners Park patiently waiting for a catch.

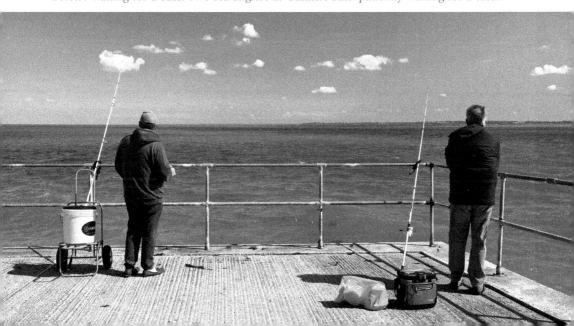

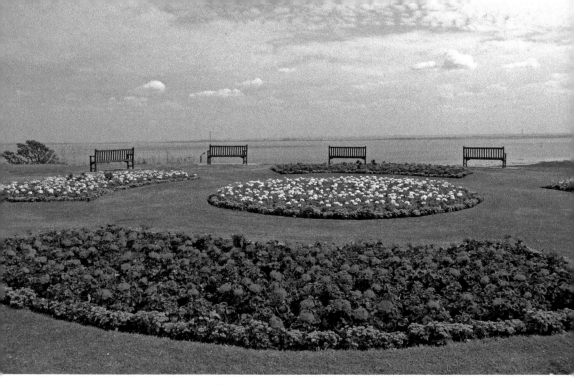

Marine Parade Gardens, Leigh-on-Sea.

Marine Parade Gardens

The third-largest area is at Marine Parade Gardens and the Belton Hills, which is at Leigh-on-Sea and is around 25 hectares. Marine Parade itself is on the same level as the town's main shopping area, the Broadway, which is just east of St Clements Church. Down the hill, which can be accessed across the newly laid pathways, is the railway station and Old Leigh High Street. Here there are old public houses, the old customs house and the cockle sheds. At the top of the hill is a seating area with cultivated flower beds and views of the river.

The Shrubbery and the Cliffs

Visitors to Southend seaside, however, are probably more familiar with the Shrubbery below the Royal Hotel and Terrace. Prince Arthur walked there during the early morning before attending the Shoebury Gunnery School. Princess Louise, the Marchioness of Lorne (later the Duchess of Argyle), also walked in the Shrubbery several times during her stay at Southend.

In 1937, a café was built below the Terrace, at the bottom of the Shrubbery. It cost £1,500. On the same site, until recently, there was Fishermans Wharf, a fully licensed 'Fish, Seafood and Grill Restaurant', which has now been demolished. Adjoining the Shrubbery and leading to the west as far as the Cliffs Pavillion at

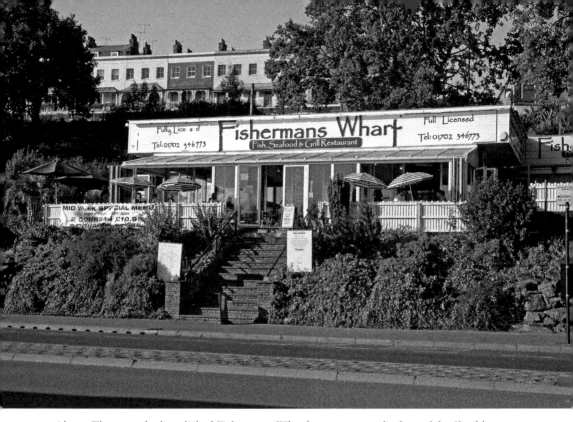

Above: The recently demolished Fishermans Wharf restaurant at the foot of the Shrubbery.

Below: A view from the cliffs of the Thames at low tide after sunset.

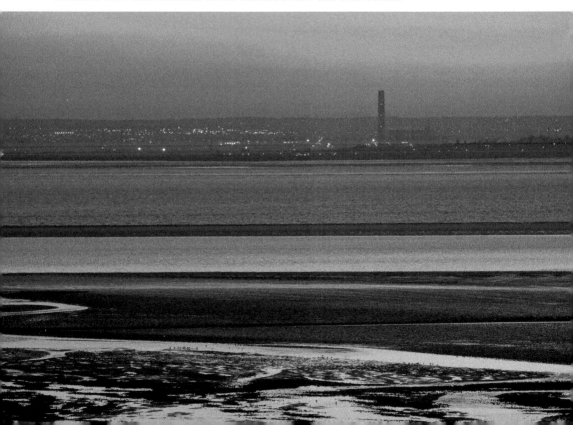

The sun is below the horizon. Lights on the Kentish coast are turned on, including those on the power station chimney which has now been demolished.

Westcliff is the Southend Cliff Gardens. From here can be seen beautiful sunsets and magnificent views of the Kent coast across the Thames. At the top of the cliffs there are several structures of historical interest.

The first of these structures is at Cliffton Terrace, a short distance west of the Royal Hotel and Royal Terrace. Here there is a 4-foot 6-inch-gauge funicular railway which, at 130 feet in length, is the shortest in the United Kingdom. When open it enables people to reach the Western Esplanade below and to then walk across the main road to the beach without using the stairs on the lift's eastern side or the several pathway routes through the gardens. The original railway was built by R. Waygood & Co. Ltd and opened in August 1912, so there has been a funicular railway here serving the local community and visitors for over a century.

West of the funicular railway, on Clifftown Parade opposite Devereux Road, there is a Grade II listed Victorian shelter. There is another set back from the roadway before the war memorial, which was designed by Sir Edwin Lansdeer Lutyens (1869–1944); and a third can be seen further west, opposite Wilson Road. It was in 1883 that Lloyd Wise (later Sir Lloyd Wise) first suggested visitors to the town needed somewhere to sit, relax and perhaps read a book as they would not want to stay on their feet all day. Nearly a decade later, in early January 1892, Mr Bridgland moved a motion at the meeting of the Southend Local Board for two shelters to be erected on the cliff green at a cost of £25 each. On 13 January

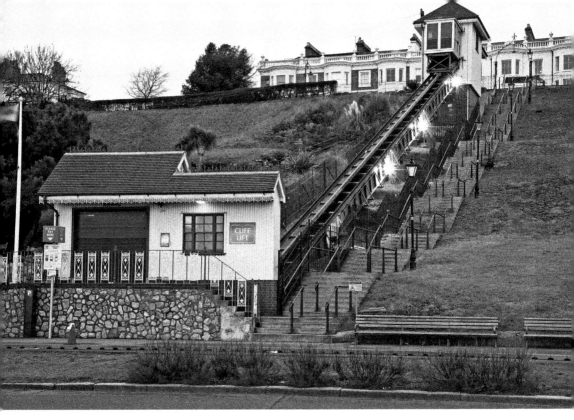

The funicular railway on the Southend Cliffs is operated by volunteers.

the Southend Local Board invited tenders for the construction of the same. During the mid- to late 1890s other shelters followed, including the third one on the cliff's green, and several were built along the western promenade. All were iron and timber structures with a lead roof.

A more recent addition to Clifftown Parade is the Queen Victoria statue, which until 1962 was sited at Pier Hill, forward of where the Royals Shopping Centre now stands. The statue is made of Carrara marble quarried in the Tuscany region of northern Italy. It was delivered to Southend in 1897 and unveiled in 1898.

West of the statue on the opposite side of the road is Southend's oldest park, Prittlewell Square Gardens, complete with water fountain. Opposite the gardens is an open space which once housed the Southend Cliff bandstands. Southend was keen to increase summer entertainment at its seaside resort. During a meeting on 12 March 1902, Southend Council had made the decision to invite tenders for the building of a bandstand on the cliffs. The estimated cost was £500. Two days later an application for the loan of £500 was submitted to the local government board. In 1908, however, it was decided the bandstand should be replaced at an estimated cost of £750. The new bandstand was opened on Saturday 29 May 1909 by Hannah Ingram, the wife of the mayor, and estate agent James Colbert Ingram. The Royal Marines were in attendance and their opening number was the national anthem. The bandstand proved popular and, because of its elaborate design, was known as the 'Cakestand'. At the end of January 1957, however, the

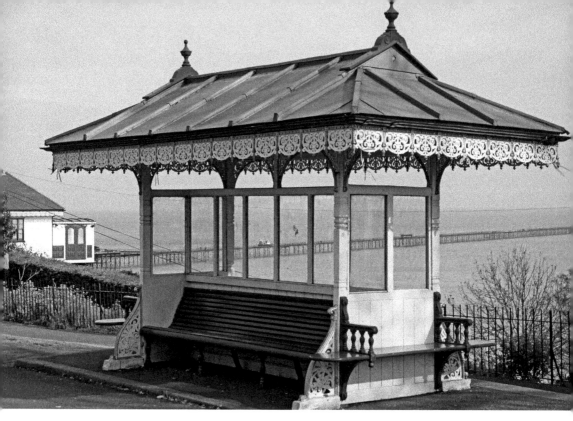

Above: One of the surviving Grade II Victorian shelters of the 1890s situated near the funicular railway.

Below: The Queen Victoria statue which until 1962 stood near the top of Pier Hill. Note the Victorian shelter at a distance on the right.

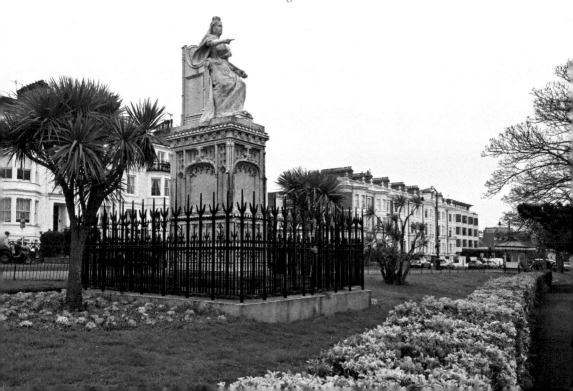

Above: Always well maintained, Prittlewell Square Gardens is Southend's oldest park.

Below: A bandstand that once stood on the cliffs is now at Priory Park.

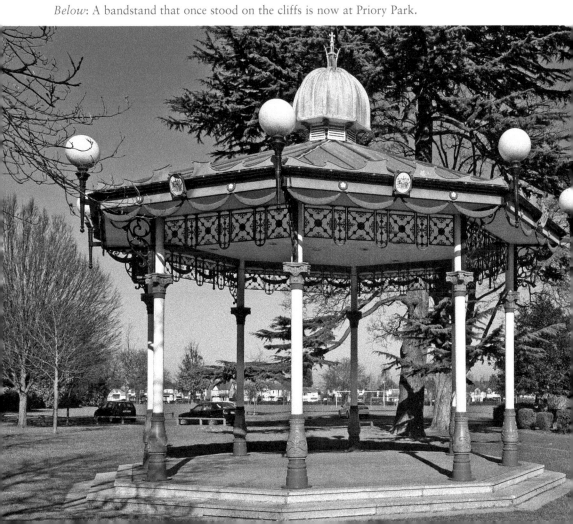

These three shelters, which stood on the site of the old bandstand, had to be removed due to the unstable nature of the cliffs.

'Cakestand' was demolished and later replaced with another bandstand, termed a 'band stage', which was considered more appropriate to modern entertainment. Modern entertainment had its problems, however, for Kathy Benson was dismissed for wriggling her hips while singing 'Lollipop'. The *Evening Standard* held a fashion show there in 1959.

Another bandstand was installed in 1990, replacing the band stage, but this was later taken down due to land slippage at the cliffs. In 2008, having had some renovation work done to it, the bandstand was erected at Priory Park as a temporary measure but remains there to this day. Three open-sided canopies on a concrete base were later erected on the old bandstand site but further erosion of the cliffs mean they too have been taken down.

Priory Park

Priory Park was once home to the Cluniac monks, where there stood a church, priory and convent. It was built in the very late eleventh century or very early twelfth century. The surrounding area is perhaps one of Southend's most popular open spaces, where a variety of sports can be played on its southern side. There are two old ponds on its northern side which were once fished by the monks and

Above: A well-maintained, enclosed garden in full bloom north of the priory at Priory Park.

Below: Prittlewell Priory, once home to the Cluniac monks.

can still be fished today. Nearby is Prittle Brook, which flows into the Roach, which itself flows into the Crouch. There are a variety of plants, trees, and shrubs growing throughout the park that attract many different species of wildlife. Near the priory there is a well-maintained enclosed garden complete with a water feature.

Stanley Thomas Jermyn, Botanist

Stanley Thomas Jermyn (1909–73) was a botanist of note who visited Southend's open spaces. At one time he had worked in a Southend warehouse. He was an active member of the Botanical Society of the British Isles and a Fellow of the Linnean Society of London. Stanley was born near Southend, at South Benfleet. He was the son of James Jermyn, a waterworks engine driver, and his wife Amy (Rachael Amy Lambert). Stanley wrote the *Flora of Essex* which was published posthumously in 1974. Although his main focus appears to have been on Essex, he collected plant specimens throughout England. He also collected in Wales, Scotland, Jersey, the Scilly Isles, Northern Ireland, the Republic of Ireland and even Austria. Many plant specimens from his herbarium are held at the Smithsonian Museum of Natural History in the United States of America. Included in the collection are specimens from Southend. Only one specimen is actually noted as from Southend-on-Sea, but there are several from Prittlewell, Westcliff Gardens, one from Southchurch and several from Leigh rubbish tip. One specimen, *Trifolium arvense*, or rabbit-foot clover, he collected at Belfairs Nature Reserve on 6 July 1946. He collected another *Trifolium arvense* on 5 August 1955 at Warren Road, Belfairs. *Vicia bithynica* was collected on 12 June 1949 on the slopes above Leigh railway station. In later life Stanley moved from South Benfleet to Felstead, which is where he died. Through his efforts it may be said that a little piece of the city of Southend is housed in an American museum.

Southend Pier

At the end of the eighteenth century and during the first few decades of the nineteenth century when the town of Southend was in its infancy, visitors usually travelled down from London by horse and chaise or by horse and coach. Occasionally they would sail down the Thames and on arriving at Southend would transfer to a rowing boat to reach the shore. The river route, however, proved problematic at low tide, denying rowing boats access to the beach. A wagon, cart or, for the more affluent, a carriage, was sometimes sent across one of the two causeways to collect the passengers. No doubt this would have been on William Heygate's mind when he began to campaign for the building of a pier. It was thought a pier would encourage more visitors to the town, encourage further

Southend Pierhead as seen from the cliffs after the sun had set.

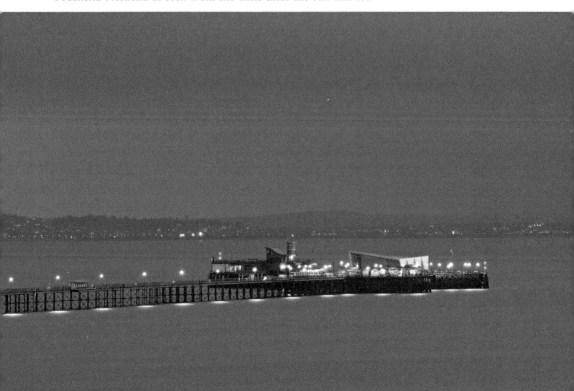

development, and so increase prosperity for the town's inhabitants. In short, it was hoped Southend would capture some of the trade that would otherwise go to Margate.

William Heygate, who was Lord Mayor of London for the session 1822–23, and his father James, who had bought much property at Southend, stepped up their campaign for a pier to be built and gained support from others. In March 1829, it was stated the capital to be raised would not exceed 240 shares, which were offered at £50 each, making a total working capital of £12,000. The share offering, however, was not a public one, but available only to the nobility, clergy and certain prominent individuals. A bill to construct a pier was put to the House of Commons and then to the House of Lords where, after several amendments, it was approved at its third reading on 7 May 1829. Royal assent was granted on 14 May.

The first general meeting of the Southend Pier Company followed, which was held at the Bank Coffee House, Cornhill, City of London, although subsequent meetings were held at the George and Vulture Tavern, also at Cornhill. The chairman at that first meeting was the previously mentioned William Heygate. On the appointed committee were Sir Thomas Maryon Wilson (7th Baronet), Major General Strutt, J. W. and J. Heygate, George Greaves, D. Blissett, J. Finlay and D. Smith. The treasurer was Robert Greenwood, a banker of Chelmsford who held three shares in the Southend Pier Company on his death in 1835. He also held property at Nos 2 and 3 Southend High Street. The clerk of the company was the solicitor Edward Mackmurdo.

On 27 June 1829, the Southend Pier Company placed an advertisement in the _Morning Advertiser_ inviting tenders for the supply of the building materials:

Ninety English Oak Trees, thirty of which to be 24 feet long, and the remaining sixty 30 feet long, all to be 12 inches in diameter, 14 inches from the butt ... also, about Sixty Loads of sound Memel or Dantzic Timber fifty feet long and upwards; at per foot run, 5000 feet of good sound yellow Memel or Dantzic Plank, three inches by eleven inches...

Less than one month later, on Thursday 23 July, the then Lord Mayor of London, Sir William Thompson, came to Southend to visit the Crowstone at Chalkwell Bay where he was to officiate a ceremony to reinforce the City of London's claim over the Thames west of that point. He was due to do similar at Yantlet Creek on the River Medway the following day and so left Southend for Rochester where he stayed overnight. However, Thompson agreed to return to Southend to lay the pier foundation stone, which he did on Saturday 26 July. A total of 600 feet of the pier, with a width of 20 feet, had been completed by June 1830 and from then until September the pier had extended 1,500 feet out to sea. It soon became clear the pier was only suited for use at high tide, so it was decided a pierhead should be constructed with the intention of connecting it to the existing pier, giving a total length of around a mile.

The pierhead was built in 1833 over a period of eight months. It was constructed with thirty-eight piles of Memel fir timber, each being between 12 and 14 square inches. These were sunk into the sand and clay at a depth of between 8 and 10 feet with an inclination of 1 in 8. Most of the piles were covered with a copper casing. The horizontal beams were each 13.5 square inches. The upper platform, which at its greatest length measured 100 feet, was 25 feet wide and constructed of fir timber planks. Each plank was coated with pitch and tar before insertion. The platform was sited 25 feet above the spring tide low-water mark.

By 1835, the pier had made its debut on admiralty charts and a red light was installed at the end of the pier in 1840. Good quality materials were used for the pierhead's construction, but unfortunately nature caused its early demise: not from high winds and rough seas, but by the attack of *Teredo navaris*, a bivalve mollusc often referred to as 'shipworm'. These were noticed just six months after the construction was completed and within a few years the 'shipworms' had eaten well into the piles. Six replacement piles made of English oak were used as a temporary measure to prolong the stay of the pierhead, but it was later found to have sunk by 9 inches on its western side. Inevitably, the pierhead had to be demolished and a new one erected.

The construction of the pier extension and the new pierhead began in 1844, but for various reasons was not completed until 1846. It was designed by James Simpson VP Inst CE who, with the assistance of resident engineer John Paton, oversaw the building work. This was carried out firstly by James Walker, but apparently completed by a Mr Hall. In all, 450 piles were used, of which 242 were cast iron between 12 to 29 feet in length; 162 were oak and 46 fir fender. Forty cast-iron piles were used for the pierhead itself, with fir timber piles fitted into them. Fir fender was used for the attaching of ropes. Each iron pile was sunk to a depth of 8–10 feet as before. The greatest extent of the new pierhead was on the upper platform and measured 102 feet by 46 feet. It had a larger area than the previous one, but was at the same 25 feet above the low-water mark for the spring tide.

The lower and middle platforms were both 5 feet 9 inches in width, with the lower platform going only halfway round the pier. The middle platform, which was constructed of fir planking, covered the whole perimeter. At the point where the platforms overlapped, they were separated by a height of 7 feet 8.5 inches. The upper platform was 8 feet 3.5 inches above the middle platform and was constructed of oak planks, as was the lower platform and the stairs giving access to all three levels.

Materials from the old pierhead were recycled where it was possible to do so. Even the lighthouse was reused, having been repaired, repainted and fitted with a new galvanized-iron roof. It was placed on the pierhead in a similar position to that which it occupied on the old one.

On 5 June 1846, Henry Choules of the Royal Hotel placed an advertisement in the *Essex Standard*: 'H Choules of the Royal Hotel has great pleasure in informing

his friends and the public that the completion of the pier at Southend enables parties to land or embark at all times of the tide.'

He appears to have been a little early, for the new pierhead and extension did not officially open until 1 July 1846 when the Loan Commissioners for Public Works took possession. However, soon after on 28 August, Shuttleworth & Sons entered the pier for auction at the Auction Mart on the corner of St Bartholomew's Lane and Throgmorton Street, City of London, by order of the Commissioners. The bidding reached £16,900, but did not reach its reserve so was bought in. On 25 March 1847, Shuttleworth & Sons announced in the *Morning Herald* that Southend Pier was disposed of by private contract to the Eastern Counties Railway. The original plan for the London, Tilbury & Southend Railway was for the Southend terminus to be near the pier, but it would likely encroach on the grounds of the Pier Company, so as a legal safeguard the railway company bought the pier for £17,000. Seven years later, on Tuesday 29 August 1854 during the half-yearly accounts meeting of the company held at the London Tavern in Bishopsgate Street, London, it was announced the Southend Pier had been sold to Messrs Peto, Betts and Brassy, the railway contractors and lessees of the Tilbury and Southend line. The principal person of that company was Sir Samuel Morton Peto, an entrepreneur and civil engineer who was involved in the construction of Nelson's Column and the Lyceum. Money, however, did not change hands as the agreement was that Peto & Co. would not pay the £20,000 sale price until twelve months after the completion of the Tilbury to Southend line, although interest was

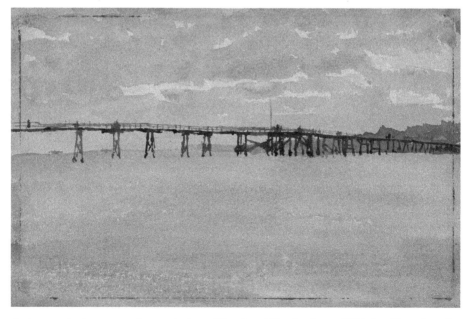

An impressionist watercolour painting of Southend Pier by James Whistler. Note the piles are inclined at 1 in 8. (Courtesy of the Freer Gallery of Art)

regularly paid on the £20,000. It is from the executors of Brassey's estate, however, that the Southend Local Board bought the pier in 1875 at a cost of £10,000, plus expenses of £1,695, for which a loan of £12,000 was received. The pier, however, was in a bad state and Mr Bull, a surveyor, estimated a complete overhaul to be £3,588, but that essential immediate repairs would cost £1,500.

In 1885, work was done on the approach to the pier, with the building of the tollhouses and the adjoining shops at a cost of £5,500.

In 1887, it was decided the old wooden pier had had its day and should be replaced. Iron was chosen as the preferred material for the main structure of the new pier, which was built alongside the old one. A part of the new pier was open for promenade purposes on 8 July 1889. The pierhead was far from complete and concerns were raised about some of the workmanship and the quality of the timber used. At 9.30 p.m. on Thursday 29 May 1890 disaster struck the old pier when 300 yards of it caught fire. The fire was still burning at 1 a.m., although by this time it was largely under control. A small section of the old pier caught fire on the previous Sunday afternoon, so this was the second fire in only a few days. Fortunately, the fires did not cross over to the new pier, which had cost £68,000 to build – £63,000 of which was covered by a loan. An additional £1,100 came from the sale of timber salvaged from the old pier.

The horse-drawn tram used on the old pier was considered too dangerous as it had been involved in several serious accidents, including the death of Kesiah Musson Little in 1887. A safer means of transport was therefore required for the new pier. A steam train was considered but quickly ruled out because of its weight and the unpleasant smoke which would have no doubt annoyed people walking the pier promenade. An electric railway was eventually chosen based on the plans of the well-respected Dr John Hopkinson, a Fellow of the Royal Society, who was also the appointed consultant engineer for the works. Tenders for the railway were soon open and the contract was awarded to Crompton & Co. of Chelmsford. The proposed tramway would run on a 3-foot 6-inch-gauge track ¾ of a mile in length. The rails were of the flat-bottomed vignolle type introduced to this country by Charles Vignolle in 1836 when used on the London and Croydon railway. The powerhouse was situated in one of the arches below the pier entrance where a steam engine would drive a Crompton dynamo of 150 amperes and 200 volts, connected to the start of the tramline by large copper cables. One of these cables was connected to a conductor strip of 1 inch by 0.134 inch which was fitted 12 inches away from the inside of the rail on the east side at a position 1 inch below the top of the rail. Glass insulators were installed every 15 yards supported by straining gear with volute springs affixed at every 85 yards. Another cable was connected to the rail returning the current to the dynamo. Each car was fitted with Crompton motors. On 1 August 1890 the tramway was tested and it opened to the public the following day. A one-way trip on the old pier would take around fifteen minutes by horse tram, but now a similar trip could be achieved on the new pier in around four minutes. Dr Hopkinson was very pleased with

the completed works. Sadly, he died a few years later. Dr Hopkinson had visited the Swiss Alps and on 27 August 1898 he set out from his hotel with three of his children – John, Alice and Lina – to climb Petite Dent de Veisivi. His wife and the two younger children stayed behind at the hotel. When Dr Hopkinson did not return, two search parties set out to look for him. One of the search parties found his body and that of his children roped together at the foot of a precipice. He died at the age of forty-nine.

The equipment used to run the tramway during the day, incidentally, was used to light up the promenade at night and was also employed to light up the new Pavilion, a welcome relief from the previously used gas lights.

In 1898, however, the new tramline was partially destroyed when the ketch yacht *Dolphin* dragged its anchor and crashed into the pier between the fourth shelter and the pierhead. The pier was also extended by 150 yards in this same year. A further collision with the pier occurred in 1908 when the Thames Conservancy hulk *Marlborough* broke anchor during bad weather, leaving the pierhead and the new bandstand an island. A Leigh fishing boat also broke anchor, crashing into the shore end, although the damaged caused here was much less marked than that near the pierhead.

Collisions continued to occur and in 1921 the *Violatte*, a ferro-concrete oil engine vessel of 292 tons of Antwerp, broke its mooring, crashing into the pier and causing damage that expanded some 160 feet. The Ipswich barge *Mathilda Upson* crashed into the pier in 1933. Other collisions occurred in later years, most notably the MV *Kingsabbey* in 1986, which severed the slipway for the lifeboat and caused damage to the boathouse.

The shore end of the pier as seen from the east at sunset.

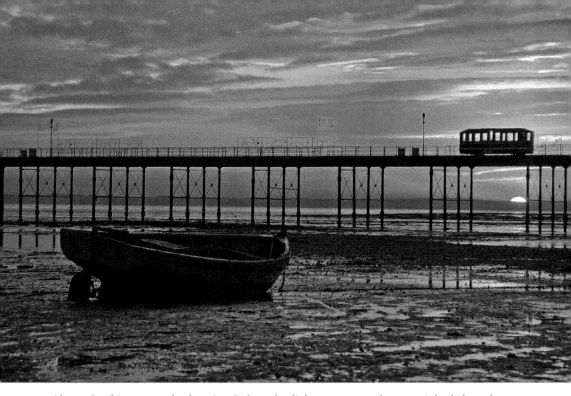

Above: Looking towards the pier. Before the lights come on the sun sinks below the horizon producing beautiful sunsets.

Below: The Park Inn Palace Hotel overlooks the shore end of the pier. The roof extension is a 2006 addition.

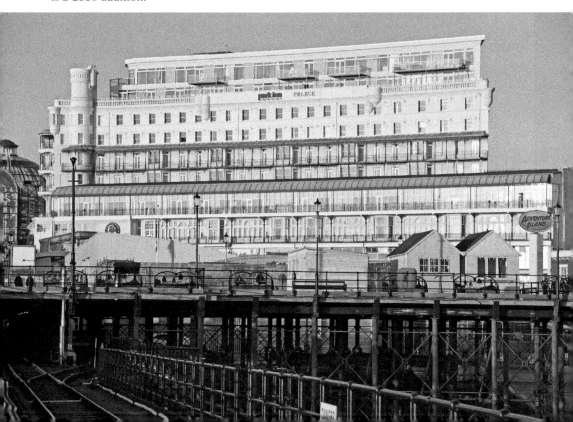

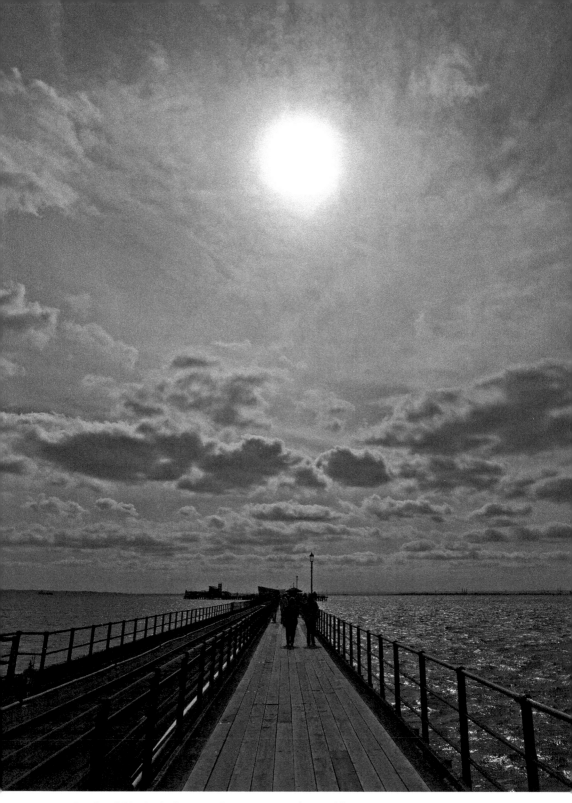

Southend Pier is the longest pleasure pier in the world.

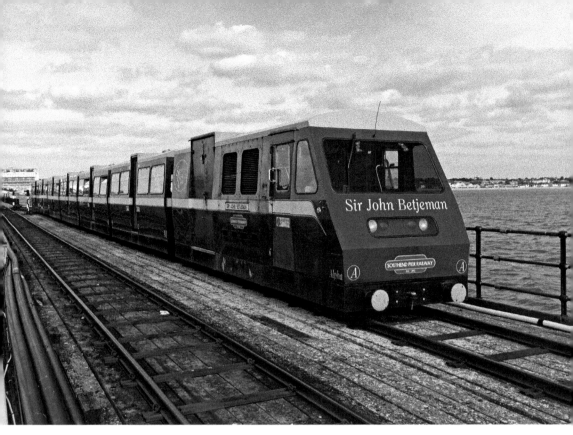

Above: The Sir John Betjeman train parked at the loop. The carriages have been recycled and are now used on the pier as public shelters.

Below: A close-up of the *Sir John Betjeman* power car.

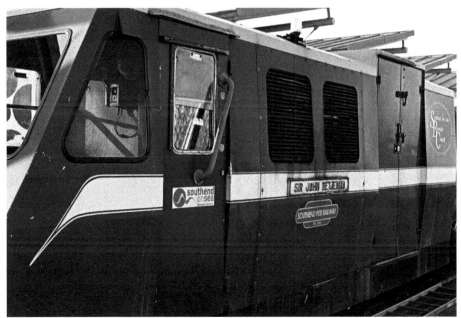

Despite these collisions and others, the pier was restored to an operational state on each occasion. There was, however, a major fire at the shore end of the pier in 1959 that completely destroyed the pavilion. It was replaced by a ten-pin bowling alley in 1962. The bowling alley, too, was destroyed by fire, in 1995. Another fire had occurred at the pierhead in 1976 and again in 2005. Despite this the structure was named Pier of the Year in 2007 and in 2012 the pier railway achieved Guinness World Record status by being named the longest pier railway in the world. At the time the trains serving on the line were the *Sir John Betjemin* and the *Sir William Heygate*. Both trains had been introduced in 1986, replacing the earlier trains of 1949, which in turn replaced what was known as the 'toast rack trains'. The *Sir John Betjemin* and the *Sir William Heygate* were replaced by two new trains in 2021, which became fully operational in the autumn of 2022. The new trains are the *Sir David Amess* and the *William Bradley*. In April 2023, Southend Pier was named Pier of the Year 2023 by the National Pier Society. In 2030, it will be time for the city of Southend to celebrate its pier which, in one form or another, would then have been there for 200 years.

The *Sir William Heygate* pier train with the Kent coast in the background.

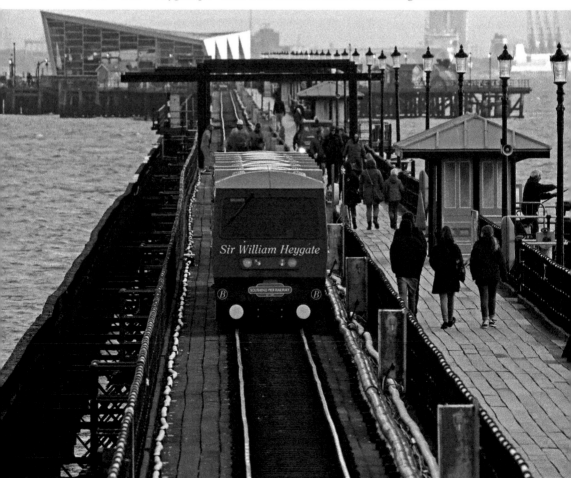

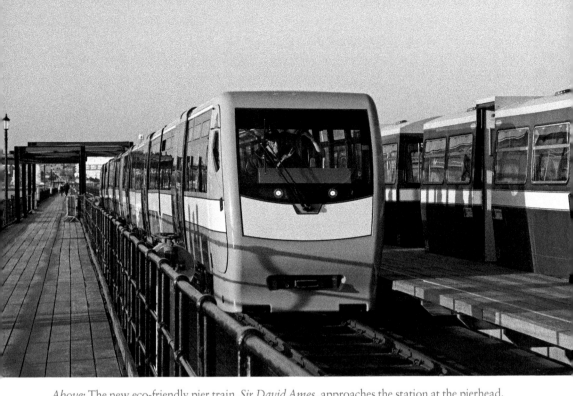

Above: The new eco-friendly pier train, *Sir David Ames*, approaches the station at the pierhead.

Below: Safety first. Warning notices tell people to keep off the track.

Above: A points lever on the pier railway at the south end of the loop. Behind the lever is a fire equipment storage box.

Below: A talking telescope at the end of the pier.

Above: The pierhead on a fresh, chilly, bright winter's day. Two seated people on the right, well wrapped up, are enjoying the sea views.

Below: There are several places to buy food and drink at the pierhead, including the ubiquitous fish and chips.

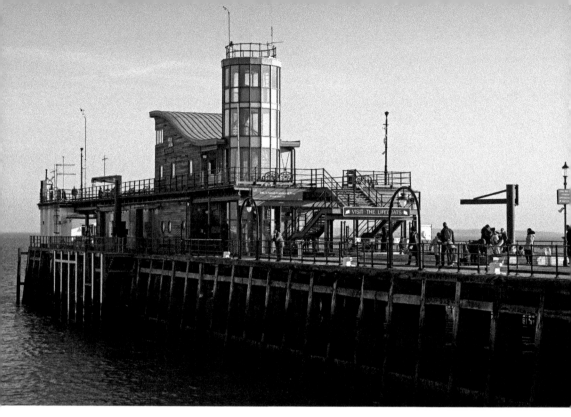

Above: Southend Rescue. The lifeboat station tower at the end of the pier.

Below: Looking towards Southend from the end of the pier.

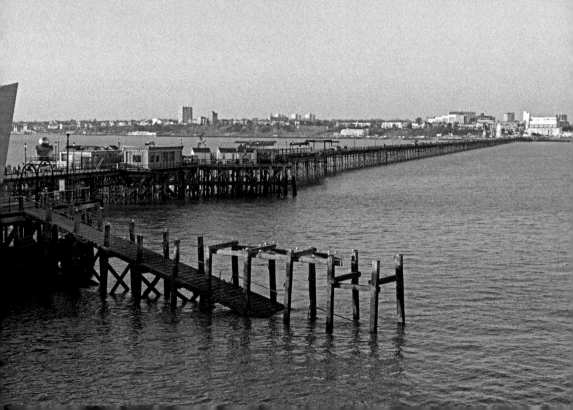

The River Thames and the Thames Estuary

The mighty River Thames is of small beginnings, rising from several springs at a place called Thames Head in the parish of Cotes, which is 3 miles south-west of Cirencester in Gloucestershire. On leaving that county the river flows through Wiltshire, then Oxfordshire where it is joined at Dorchester by the River Thame. From its source to the Thame the river is often referred to as 'the Isis'. The Thames then meanders its way through the countryside of Buckinghamshire before entering Berkshire and on to Surrey. On leaving that county it flows through Greater London where, at Teddington Lock, the level of the river drops and becomes tidal. After exiting Greater London, the Thames separates the north coast of Kent from the south coast of Essex as it flows towards the city of Southend. Within the western boundary of the city, between Leigh and Westcliff, there is Chalkwell. Here can be seen the now disused Crowstone (Crow Stone), the last of the granite obelisks which were used to mark the north coast boundary of the eastern end of the Thames within the jurisdiction of the City of London.

A few miles east of the Crowstone is where the Thames Estuary begins. There is no precise point, but it is generally considered the estuary covers an area from Southend-on-Sea to the Naze of Harwich on the north coast, and from Sheerness on the Isle of Sheppey to Foreland Point on the south coast. It is near Sheerness where the waters of the Medway flow into the mouth of the Thames, between the Isle of Sheppey and the Isle of Grain.

Then 3 miles north-east of Sheerness and just over 3 miles south-south-east of Shoeburyness there is a shoal called the 'Nore', which is a suitable place for the anchorage of ships waiting to enter the Medway or to proceed along the Thames to London. The Nore comprises the Great Nore and Little Nore, the latter being closest to the mouth of the Medway.

In 1801, Nelson was sent to the Little Nore. He was Commander-in-Chief and assigned to the frigate *Amazon* under the captaincy of Samuel Sutton. The many vessels at his disposal were minor; nothing near the scale of the *Victory*. The aim was to protect the coast, to stop the French from landing on British soil, and to protect the river route to London.

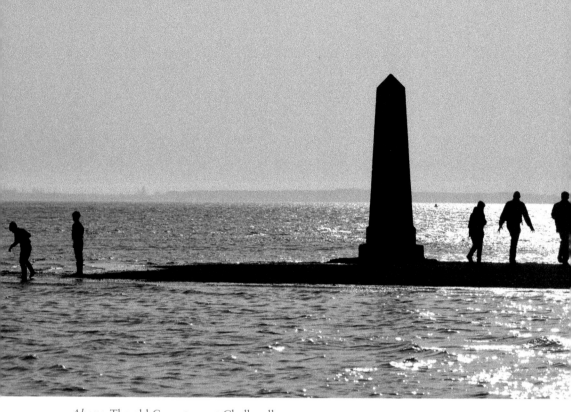

Above: The old Crowstone at Chalkwell.

Below: A man on the left and a woman on the right take photographs of the Thames and the estuary from the observing platform at the Cliff Lift near the pier.

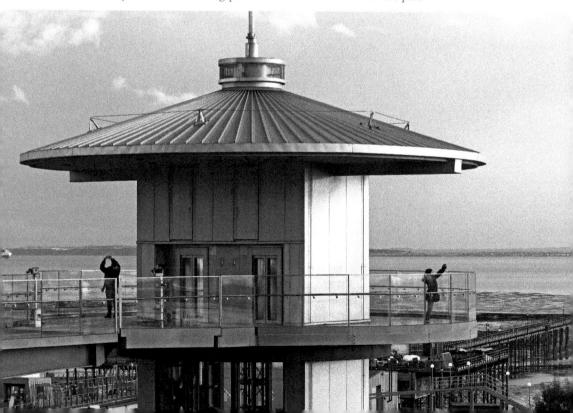

One French ship, however, did get through the British defences – by flying a British flag – in February 1802. It was the frigate *Egyptienne*, a ship that was captured by the British at the harbour of Alexandria in Egypt. The *Egyptienne* was on its way to Deptford when it sailed by Southend shores carrying the fragment of a granite stone stella scribed in two languages but in three scripts: Egyptian (Hieroglyph and Demotic script) and Greek. The fragment, transported under the care of Sir Tomkyns Hilgrove Turner, who had loaded it onto the ship at Alexandria, was the Rosetta Stone, a key to deciphering the lost and ancient language of the Egyptians. It is now on display at the British Museum.

The estuary, however, with its shifting sands and sometimes shallow waters, can be a hazardous place for shipping. Vessels have to carefully navigate along the correct channels in order to safely reach their destinations. They are assisted by the many buoys marking the channels.

The Lightship

During the early eighteenth century and before, proposals were put forward to place lightships at dangerous points along the British coast, but all such proposals were ignored. Captain Robert Hamblin, however, discussed his plans for a lightship with David Avery who advised him to file a patent. On 4 July 1730, Hamblin's 'method of distinguishing lights which may be perfectly known from one another' was granted by George II. In 1731, the first lightship, the *Experiment*, entered service and this was anchored at the Nore. Trinity House, however, objected, and on 4 May 1732 Hamblin's patent was made void, even though his lightship was considered beneficial to mariners. The following year Hamblin and Avery reached an agreement with Trinity House whereby they were granted a lease to use the lightship for a period of sixty years at a cost of £100 per annum. Mariners paid for the upkeep with Hamblin and Avery reaping any profits.

The original Hamblin lightship appears to have been a Dutch sloop with two large lanterns attached to the mast of the ship. A distance of 12 feet separated the lights. According to a *Dictionary of the Thames* (1894) by Charles Dickens, the two large lanterns were changed to one fixed light in 1825. The 1825 ship was replaced thirty years later by a vessel with a revolving white light, flashing every thirty seconds. The replacement vessel was built at Limehouse. It was 96 feet in length and 21 feet broad. The lightship's signals were answered by the Southend lifeboat station, which was established in 1879 when Southend received its first lifeboat, *The Boys of England and Edwin J. Brett*.

An insight into life on board the lightship is given be Robert George Hobbs in his *Reminiscences of Seventy Years Life, Travel, and Adventure* (1895). Hobbs was a former civil servant who had spent forty years at Sheerness and Chatham dockyards. He gives an account as told to him by one of the lightship's crew.

'There are eleven hands belonging to the ship – the master, the mate, three lamp lighters and six seamen', with seven persons on board at any one time. The ship's personnel were relieved on the 15th of each month. The master and mate would spend one month on board and then one month on shore. The rest of the crew would also have one month ashore but their shift on board would be for two months at a time. Their day afloat commences 'at seven bells (7.30); all hands then turn out, lash up their hammocks and get breakfast ready for duty', but two hands stay on deck all night. The crew's first duty of the day was to ensure the ship was cleaned, especially the nine lamps and nine reflectors in the lantern which was the responsibility of the lamp lighter. At the time of the 'dog-watch, which is four to eight in the evening, we have a little music on the accordion and singing'. They had a chaffinch on board named Jackey: 'You will find Jackey is all there when any music or singing is going on.'

Surveying the Thames

Between 1790 and 1810, Lieutenant Murdoch Mackenzie and his cousin Graeme Spence carried out surveys in the estuary, as did a Mr Thomas. However, Captain Frederick Bullock, whose family lived in Southend at Prittlewell, appears to have been the first to undertake a thorough survey of the river and estuary waters, producing charts for the Admiralty which became the standard. He was appointed to the Admiralty in 1830 and had carried out a survey of the upper Thames after which he proposed a survey of the estuary. It was apparently rejected, but the idea was later embraced by Sir Francis Beaufort (1774–1857) when he became hydrographer to the Admiralty in 1832. Under Beaufort's instructions Bullock carried out the survey of the lower reaches of the river and the estuary from 1835 to 1845. He had surveyed as far as from London Bridge to Margate in 1839 when he was on board the steamship *Boxer*. In 1844, he was surveying the Naze of Harwich to South Foreland on board the *Myrtle*. Captain Bullock, later Admiral Bullock, had a younger brother, William, who was born at Prittlewell on 12 January 1797. William received his education at Christ's Hospital in London where he no doubt had a good grounding in the skills of navigation. In 1821, he was an astronomical surveyor and in command of the *Inspector*. On board was his brother, the then Lieutenant Frederick Bullock, who had joined the naval service as a 1st Class volunteer on 28 November 1804. It would therefore appear Frederick learned his surveying skills from his younger brother. William was later ordained deacon at St James Piccadilly, London, on 3 March 1822 by George Henry Law, the Bishop of Chester. A month later, on 14 April, he was ordained priest at St Marylebone, also in London, by George Pelham, the Bishop of Lincoln. He then went to the Mission in Trinity Bay, New Foundland, where he was ordained by the Bishop of Nova Scotia. There Revd Bullock

continued working as a surveyor. He died on 7 March 1874 and is buried at the Camp Hill Cemetery in Halifax, Nova Scotia. At the time of his death he was rector of the Cathedral Church of St Luke. William and Frederick's father, Captain James Bullock, was buried at St Mary Prittlewell in 1825.

Maplin Lighthouse

It was in 1837, during the period of Bullock's survey, that James Walker (1781–1862), the engineer-in-chief at Trinity House, began to drill bore holes on the Maplin Sands as part of a feasibility study for the erection of a lighthouse. He chose a site on the eastern edge of the sands, 5 miles from shore and about 10 miles from the Nore lightship. Walker found the sand was compact down to about 6 feet, but from there the boring rod had an easier passage for 20 feet or so where the sand was mixed with more and more clay as the rod descended. Walker decided to employ screw mooring rods for the foundation of the lighthouse. These had been patented by the Dublin-born Alexander Mitchell (1780–1868). Under Walker's instructions, Mitchell (who by this time was losing his sight) and his son John began work on the erection of the lighthouse in 1838. Nine 26-foot-long cast-iron piles, each of 5 inches in diameter, were screwed into the sand, 21 feet below the low-water spring tide mark and 5 feet above it. They were arranged in

Maplin Lighthouse. (Courtesy of the Library of Congress)

the shape of an octagon with one pile in the centre. The sand was found to shift around the piles, so a wooden grating was prepared and placed over them. The grating was covered with 120 tons of Kentish ragstone. After several inspections no further problems became apparent so the superstructure began to be built during the summer of 1840. Another nine piles were used. These were 18 feet long and, with the exception of the centre column, were placed at an angle to the top so as to give a radius there of 21 feet from the centre. The door to the dwelling house was on the north-west side of the lighthouse. From 1885 to 1886 the

The Cockle Row Spit buoy now stands at the west end of Leigh High Street in celebration of Leigh's maritime heritage.

lighthouse was strengthened and the superstructure was partially restructured. A telephone cable was installed in 1885 and in early January 1886 it was connected to Southend Coastguard Station. In late August 1931, however, the lighthouse was deemed to be unsafe due to the piles being exposed by the shifting sands and the lighthouse was abandoned.

Alexandra Yacht Club

The Thames is also a place for pleasure and in 1878 the Alexandra Yacht Club became the first sailing club on the lower reaches of the river. It began life as the Alexandra Club in early 1873 and was named after the then Princess of Wales, Alexandra Caroline Marie Charlotte Louise Julia (1844–1925). She became Queen Alexandra, the wife of Edward VII. Early meetings were held at

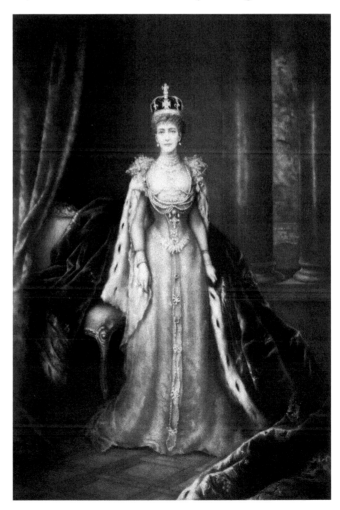

The Alexandra Yacht Club was named after the Princess Alexandra. (Courtesy of the Library of Congress)

The former clubhouse of the Alexandra Yacht Club, which was destroyed by fire in 2014.

rented rooms in the public hall on Alexander Street. Annual membership was £2
2s, or £1 1s to non-residents. Nearly half the membership were yachtsmen, so
it was voted to change the name of the club to the Alexandra Yacht Club. The
first commodore was James Forster Turner Wiseman (1835–1903), an oyster
dredger and farmer of the Chase, Paglesham, who died at Ley-Villa, Plumtree,
in Nottinghamshire. The vice commodore was John Anthony Sparvel-Bayly
of Burstead Lodge in Billericay, who died at West Ham in 1895. He was a rear
commodore of the Corinthian Yacht Club and an antiquarian, being a Fellow of
the Society of Antiquaries. William Green Brighten, a solicitor of London and of
Argyle Street, Southend, was the rear commodore. The honorary secretary was
Albert Lucking, a corn and seed merchant. He resigned his position at the yacht
club in 1886 and was presented with a liqueur stand and a binocular microscope.
He died at Acton Vale, London, in 1905. Albert was very active in the Masons; the
Albert Lucking Lodge was named after him.

Yachts at the Alexandra Yacht Club.

On Trafalgar Day 1884, before Albert Lucking's resignation, the Alexandra Yacht Club moved into the 'Indian Pavilion' on Cliffton Parade. A fire gutted the building in 1972, but it survived until another fire took hold in 2014. The second fire completely destroyed it. The clubhouse had already been vacated due to structural problems.

Continuity and Change: Modernisation of the Seafront

East of the Pier

It is probably true to say the most popular area of Southend for the summer day-tripper is the beach and amusement arcades east of the pier. This area has changed considerably over the last century or so, but a few buildings with familiar names such as the Rose Restaurant, Hope Hotel, Falcon and the iconic Kursaal dome offers a sense of continuity.

The Forrester's Arms, however, which stood across the road on the west side of the Kursaal, has recently been demolished to make way for the building of the

Next to the Hope Hotel on its western side is Monte Carlo and New York, two of the amusement arcades on Marine Parade, otherwise known as Southend's 'Golden Mile'. It is quiet during the winter months but attracts many visitors during the summer season.

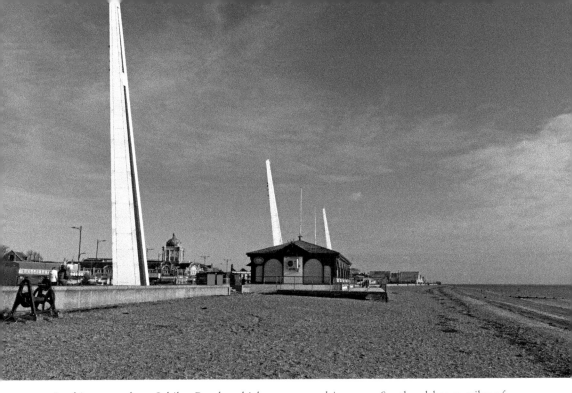

Looking east along Jubilee Beach, which was opened in 2002. Southend has 7 miles of beaches from Shoeburyness to Leigh-on-Sea. Sealife Adventure is the blue-roofed building in the distance.

Marine Plaza, which will give a sense of modernity to that end of Marine Parade with an expected completion date of 2026.

The eastern promenade skyline, however, is dominated by the six lighting masts created by StudioFractal and were introduced in 2010. Each mast is just over 20 metres high and holds 1,560 light-emitting diodes (LEDs) which have the ability to change colour. Nearby is an area with water spouts which can vary in height and are popular with the children who want to cool off in hot weather during the summer months. At night the lighting is switched on and the water feature takes on a new lease of life by displaying a variety of vibrant colours.

The seafront east of the pier from the Hope Hotel on the far left to the Britannia on the far right, showing the six lighting masts.

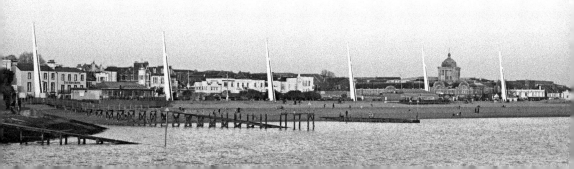

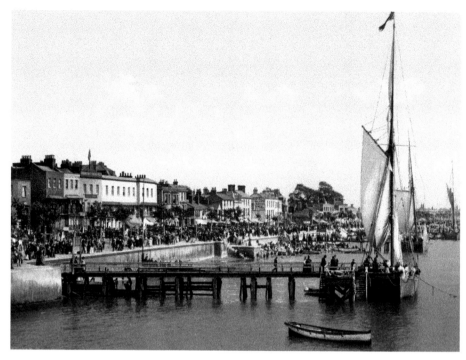

Above: The Cart Parade (1890s). The pinkish building on the left immediately above the people at the start of the jetty is the Rose Coffee Tavern (now the Rose Restaurant). The Hope Hotel is above the single figure walking the jetty. Above the first visible set of steps on the jetty is the Falcon. (Courtesy of the Library of Congress)

Below: The water spouts vary in height throughout the day and the cool water is enjoyed by children in the hot weather.

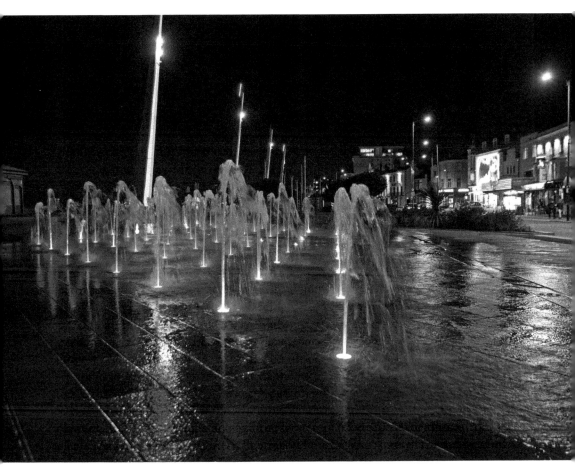

At night the lights are switched on, producing a water display of changing colours.

Central to the Pier

Between the eastern promenade and the western promenade is Pier Hill, which is a key location at the end of the High Street. The area was completely relandscaped in 2004 at a cost of around £6 million. Included in the project was a twin lift giving access to Adventure Island, the seafront and, from the lower terrace, the longest pleasure pier in the world. The observation platform at the lift offers stunning views of the Thames and of the estuary. On a clear day it is possible to see the wind farms on the eastern horizon and between the wind turbines the Red Sands Fort. The design incorporates winding pathways with complimentary planting and, on the west side of the observing platform, steps to the seafront as an alternative to the lift. Modern lighting was installed as part of the landscaping process and this contrasts with the lighting on the west side of the pier, which perhaps has a Victorian feel to it, reflecting Southend's past.

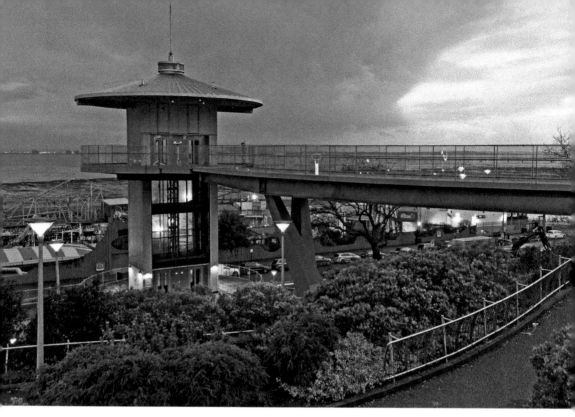

Above: The twin Cliff Lift was part of the 2004 Pier Hill redevelopment programme.

Below: Looking east from the Cliff Lift walkway across Jubilee Beach, which was opened in 2002. From here the wind farm can be seen. Between the wind turbines is the Red Sands Fort. The lighting masts are on the left and the Premier Inn is in the centre. In front of the Premier Inn is Sealife Adventure.

Above: One of the modern lights at the ground level of the twin lifts.

Below: The lights display a different colour as they begin to warm up.

West of the Pier

The area west of the pier is generally a quieter, more relaxing place, devoid of amusement arcades and without the hustle and bustle of the busy beaches on the eastern side where most people tend to congregate. Three Shells Beach and the Lagoon, which is immediately west of Adventure Island, however, is very popular with young families. In the late 1890s the area was noticeable for its bathing machines and pleasure rowing boats.

The western esplanade, however, is not without its modern developments. The Esplanade public house, restaurant and entertainment venue that stood 200 yards from the pier was demolished in 2019 and a new residential complex, Clifftown Shore, has been erected in its place. The building also houses the Zinnia Restaurant managed by the Elysium Group. There has been a restaurant on the site since at least the late 1870s. At the end of the nineteenth century the Esplanade was known as Stansfield's Esplanade Restaurant and there was

The lighting west of the pier perhaps has more of a Victorian feel and contrasts with the modern lighting east of the pier.

Above: Three Shells Beach. Looking east towards Adventure Island.

Below: Three Shells Beach and the Lagoon. The coloured 'sentry boxes' are the toilets.

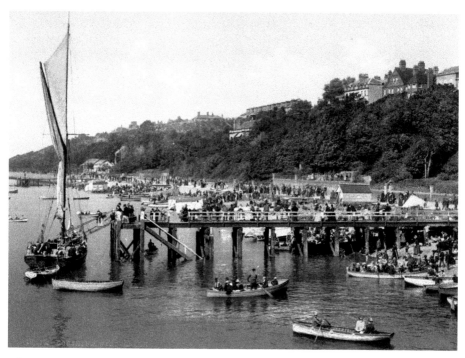

Above: West Parade. An 1890s view of what is now Three Shells Beach and Lagoon. Note the bathing machines behind the jetty. (Courtesy of the Library of Congress)

Below: Marriotts and the Esplanade were demolished in 2019 to make way for Clifftown Shore.

space to seat up to 500 people at any one sitting. It was a single-storey building managed by Alfred Drury, who was in partnership with John William Stansfield until Drury's retirement in 1899 when it was managed by a Mr Cain, Stansfield's then new partner. Cain does not appear to have been at the Esplanade for long as Bertie Thomas Pudney, who advertised himself as the new proprietor in 1903, was living there in 1901. Bertie was assisted in the business by his wife, Ada, and his aunt. Also living there was his mother-in-law. The leasehold property was sold in 1921 for the sum of £7,000 with a rental value of £70 per year. James Calcutt, a licensed victualler, was there shortly after the sale and on 5 January 1924 he allowed the restaurant to be used as a soup kitchen for the unemployed from the beginning of January to the end of March. During that period the Esplanade was known as the 'Mayor's Soup Hall'. At the end of March 1926, to mark the closing of the Mayor's Soup Hall for the season, George Whitehead, the man in charge, was presented with a gold chain for his services to the unemployed; he said 15,000 pints of soup had been served. The soup kitchen was at the Esplanade for at least twelve seasons. James Calcutt died in 1941 and his son, James Thomas Calcutt, was the restaurant manager at the time of his father's death. Marriotts fish and chip restaurant on the west side of the Esplanade was also a part of the 2019 demolition process.

The new Clifftown Shore residential complex stands on ground previously occupied by the Esplanade.

Adventure Island and the Sunken Gardens

The amusement park that is Adventure Island sits in what were sunken gardens on the west and east side of the pier. The first sunken garden to be built was Marine Gardens on the west side, which was brought about mainly be the efforts of Alderman Albert Martin. He was also instrumental in bringing about the second garden on the east side in 1929, a decade or so after the building of the first garden.

Albert Martin was in business with James Alfred Schofield under the name of Schofield and Martin, but the partnership was dissolved on 2 December 1891. Martin, however, became a sole proprietor and continued to trade as a grocer and provision merchant under the Schofield and Martin name until his death in

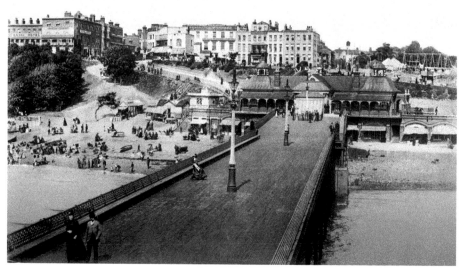

This picture taken in the 1890s shows the west and east side of the pier before the sunken gardens and the water chute basin were built. Note the fairground to the top right. (Courtesy of the Library of Congress)

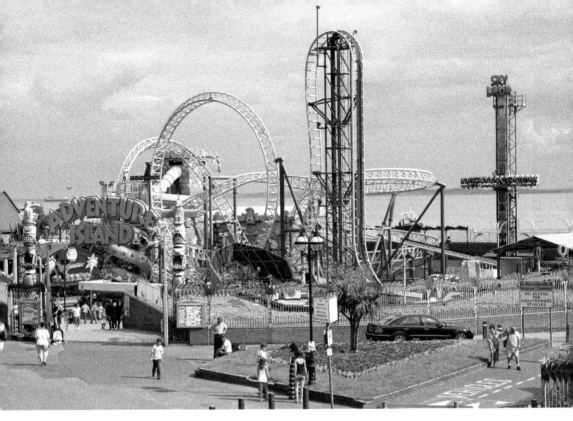

Adventure Island on the east side of the pier as seen in 2011.

1943, after which the business was acquired by the John Lewis Partnership. Albert Martin was twice mayor of Southend and he was knighted in 1938.

It was in 1901, however, before the gardens were built, that the London Westminster-based Edward Mann proposed that a water chute be constructed on the east side of the pier. Mann had agreed to pay the council 20 per cent of gross profits for use of the site and no less than £1,000 per annum. The plan was approved by Southend Town Council on 8 January 1902. Objections to the proposed water chute were made by the watermen and the pleasure boat owners. The objectors thought the water chute facility would impact their pleasure boat businesses, but the water chute was given the go ahead and construction began later in 1902. The first car trials took place in December that year. More trials followed during the following year and, with all the trials successfully completed, the water chute was open to the public at Easter 1903. Closed on Sundays, the chute was allowed to operate between 9 a.m. and 9 p.m. on other days. In early 1904, however, the syndicate operating the chute declared they were unable to continue on the agreed terms. It was decided that once the outstanding concession fee was paid the steel structure could be removed but that the water chute basin would remain. It would therefore appear the water chute was only operational for just over one season.

In January 1905, a prospectus was issued for the newly formed Weston-super-Mare Water Chute Ltd to raise 5,000 shares at £1 each. The steel structure at

Southend was transported to that place and a water chute was erected at Bernbeck Pier. The contract to remove the steel structure was given to the Rayleigh-born George Edward Croxson, an engineer and smith who set up business at Southend in 1876 and who lived at Vulcan House on Marine Parade. Croxson was apparently owed money and he found himself in financial difficulty when a receiving order was filed in 1906. Plans were later discussed to turn Southend's water chute basin into an indoor swimming pool, although an outdoor pool was favoured. This basin later became a leisure boating pool, a home to what appears to have been mainly two-seater rowing boats. In 1949, the pool became home to a full-scale replica of Sir Francis Drake's ship, the *Golden Hind*. The replica was built by local men and it was completed in just thirteen weeks. There was a waxwork on board relating to sixteenth-century life on the galleon which was put together by Louis Tussaud. This is not the same Louis Tussaud who exhibited at the pierhead in 1932. He was Louis Joseph Kenny Tussaud, the great-grandson of Madame Marie Tussaud (1761–1850). She founded the famous Madam Tussuad's waxwork exhibition, which toured England from 1802 until 1835 after which it found a permanent home at the Baker Street Bazaar and then, in 1884, the Marylebone Road, both in London. Louis Joseph Kenny Tussaud died in 1938.

The *Golden Hind* was removed from the site and replaced by a replica pirate ship which has also been removed. The basin is now home to Adventure Island Inside, which houses electronic games and a few rides for children, so the floor

Adventure Island at night with the pier in the background. This picture was taken before the arrival of the Axis ride and the City Wheel.

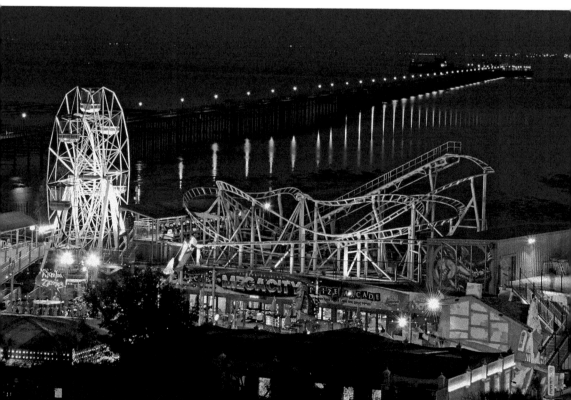

of the basin can now be walked on by the public where it was for many years underwater. Adventure Island also occupies what were the original sunken gardens on the east and west side of the pier. The area east of the pier was previously home to a boating lake for children and the Marine Garden on the west side was home to Peter Pan Playground. While the east garden has completely changed the west garden has perhaps retained some of its character. There is, for example, a fifty-two-step helter-skelter, but this is not the same yellow and red construction all so familiar to visitors in the 1970s.

Adventure Island, however, continues to evolve and offers a variety of rides for its customers on both sides of the pier. Always innovative, the amusement park in 2019 introduced the Axis ride, which is clearly visible from the south end of the High Street. At the bottom of a tall column there is a circular base with seats affixed, each facing outwards. The seats are accessed from a platform with a semi-circular cut out on each side that slots under the seating base. When safety checks are complete and the ride is declared ready, the platform moves away from the seating area by a short distance. The central column for the ride is then free to move. This column first pivots on its supports, a little like a pendulum. The circular seating base then gently rotates and the central column eventually reverses, so it is the rider's head nearest the ground rather than their feet. This gives riders of the Axis an upside-down view of the surrounding area from a height of 100 feet or so.

The latest installation is the City Wheel. It has twenty-four gondolas, two of which are suitable for wheelchair users. It occupies part of an area previously home to a 'speedway' track which had been there for nearly a century. The original

The newly installed City Wheel on the left and the Axis ride on the right.

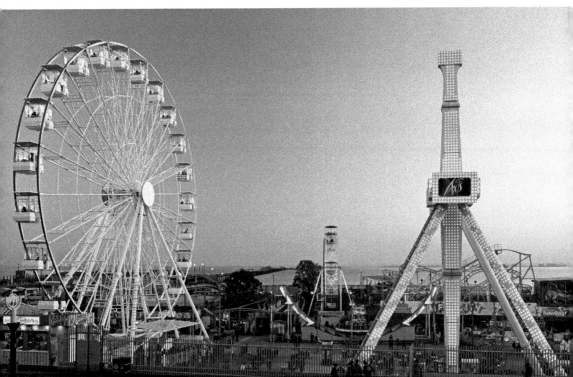

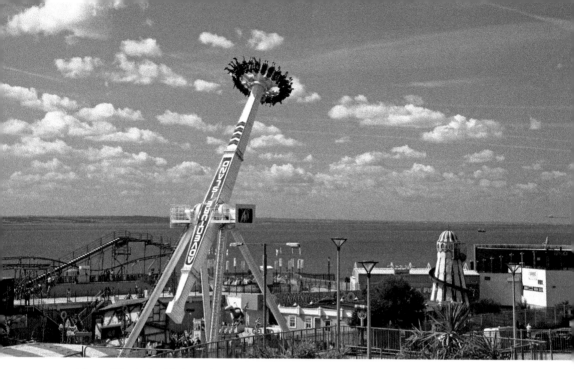

Above: The Axis ride in action.

Below: A close-up view of the upside-down seating area on the Axis ride.

track was opened in 1928 by Alderman Bradley who drove round the track in one of the ten cars. Councillors Mrs Broom and Mr Gosling followed. The City Wheel was opened on 17 December 2022 by Anna Firth MP, who succeeded the late Sir David Amess at the Southend West constituency.

Above: The Helter-Skelter with Drop 'N' Smile on the right.

Below: The Adventure Island 'speedway track' before it was removed to make way for the City Wheel.

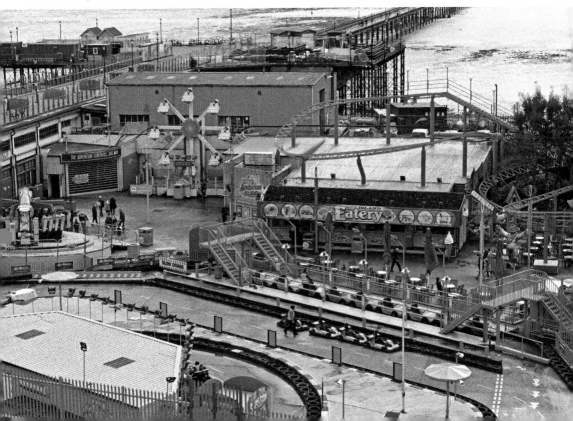

Acknowledgements

Many sources have been used in researching this book, which space will not allow me to include here. However, I have accessed numerous newspapers on the British Newspaper Archive website, and these are noted in the text. The bill from the Ship Tavern may be found in the private papers of Caroline of Brunswick (GEO/ADD/5/1-20, 1803–1821) and the receipt from Thomas Trotter in respect of the Prince Regent's gift may be found at GEO/MAIN/30035, both within the Georgian Papers Online catalogue at the Royal Collection Trust. Further information about Southend's wooden pier (by John Paton) may be found in *Minutes of the Proceedings of the Institution of Civil Engineers Vol IX, Session 1849–50*. For information about the electric pier railway, see the *Electrical Review* (22 August 1890).

All photographs in this book were taken by the author except for those stated in the caption as being sourced from the Library of Congress or the Smithsonian Freer Gallery of Art, both of which are in the United States of America.

My thanks go to St Mary's, Prittlewell, for allowing me to take photographs in the church and to the two guys fishing at Shoeburyness. My thanks also go to Nick Grant at Amberley Publishing for asking me to write this book.